The Plans That Never Happened: North Shields and Tynemouth

Malcolm Rivett

AMBERLEY

Acknowledgements

My thanks to the following:

Paul Gilmartin (pjgdesign.co.uk) for his excellent illustrations of schemes for which surviving plans are of poor quality or do not exist.

Johnston Press North East for their kind permission to reproduce many of the book's illustrations and to the staff of the *Shields Weekly News* and before it the *Shields Evening News* and *Shields Daily News* for reporting the plans proposed for North Shields and Tynemouth over many decades.

The staff of North Tyneside Libraries (and before that Tynemouth Corporation Libraries) for archiving so much material of interest.

First published 2017

Amberley Publishing
The Hill, Stroud, Gloucestershire, GL5 4EP
www.amberley-books.com

Copyright © Malcolm Rivett, 2017

The right of Malcolm Rivett to be identified as the Author of this work has been asserted in accordance with the Copyrights, Designs and Patents Act 1988.

ISBN 978 1 4456 7264 9 (print)
ISBN 978 1 4456 7265 6 (ebook)

British Library Cataloguing in Publication Data.
A catalogue record for this book is available from the British Library.

Origination by Amberley Publishing.
Printed in Great Britain.

Contents

Introduction 5

Chapter One Over and Under the Tyne 6

Chapter Two The Town Centre 26

Chapter Three Tynemouth, Queen Resort of the North East 63

Chapter Four Other Schemes That Might Have Been 75

 Conclusions 94

 Bibliography 95

Introduction

Like most towns and cities, North Shields and Tynemouth today are products of history. Their shops, offices, residential areas, transport and leisure facilities are the result of commercial and political decisions of the recent and distant past, each reflecting the prosperity or austerity, attitudes and fashions of the time. However, for every development scheme that was built as many, if not more, were proposed but never progressed beyond the drawing board. Some were hare-brained proposals making little financial or practical sense. Others were sensible ideas but were unpopular locally or there was just not the money or political will to build them. For many, their time simply passed as events unfolded and needs and fashions changed.

This book explores some of the schemes that didn't happen. These are plans for development and redevelopment that, for one reason or another, never came to fruition but now give us a glimpse into North Shields and Tynemouth as they might have been.

Chapter One

Over and Under the Tyne

About a quarter of a mile width of the River Tyne separates North Shields and South Shields and the traditional counties of Northumberland and Durham. Boats have ferried passengers between the two towns since time immemorial, although from Roman times at least until the mid-twentieth century the nearest fixed crossing of the river was the bridge at Newcastle, some 10 miles or so upstream. And even the Tyne pedestrian and road tunnels of 1951 and 1967, respectively, are 3 miles away at Howdon.

SUSPENSION BRIDGE

The width and depth of the Tyne at North Shields, and the need to maintain navigation for shipping, have always made a bridge across the river at this point a difficult proposition. Nonetheless, in 1824, Captain Samuel Brown proposed a suspension bridge between Camden Street in North Shields and the nearest point on the south side of the bend of the Tyne – what is now the end of Mile End Road. Two 209-feet-high towers were to be sited at the low-water mark of the river, some 900 feet apart. Together with 450-feet-long approaches on either side, the bridge would have a total length of 1,800 feet, the roadway standing some 115 feet above high water level.

It was estimated that the bridge would cost £93,000 and the anticipated toll income was £6,643 per annum. An undertaking to construct the bridge was formed at a

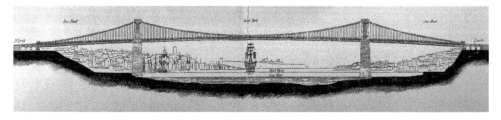

Captain Brown's 1824 suspension bridge proposal. Also pictured, under the north (left) side of the bridge, are the tall towers of the High and Low Lights, then only sixteen years old, used to guide shipping away from treacherous reefs at the mouth of the River Tyne. (Author's collection)

public meeting in North Shields in February 1825, a prospectus was published and by the end of that year more than eighty people had subscribed a total of £22,500 worth of shares. The bridge was confirmed to be a practical proposition by both the Newcastle-based civil engineer William Chapman, and Thomas Telford, whose own Menai Bridge, linking the Welsh mainland to Anglesey, was under construction at the time. Nonetheless, an anonymous letters campaign in the *Tyne Mercury* derided the proposal on many counts, including that since the people of North and South Shields were identical in their habits and occupations there was no need to a build a bridge to link them. While there is an indisputable logic to this argument, if it were to hold true there would be very little demand for transport of any type between many places.

Notwithstanding Telford's comments, the main span of the Tyne suspension bridge would have been getting on for twice that of his Menai Bridge, which itself cost more than £230,000 to build, nearly two and a half times the estimate for the Shields crossing. Furthermore, the Menai Bridge was on the main route between London and Dublin; following the 1801 Act of Union between Great Britain and Ireland the movement between London and Ireland by MPs, and others with the money to travel long distances, was rapidly increasing. In contrast, the Shields bridge would have linked two relatively small towns, both some distance off the beaten track of a main highway.

Despite the promising start, the scheme did not progress as far as securing the necessary Act of Parliament to authorise its construction. However, had it been built would it have survived until today and, if so, what would its role have now been?

The fate of many of Britain's early suspension bridges was not a happy one. Arguably the country's first such bridge, at Middleton in Teesdale (County Durham), dating from 1741, collapsed in 1802 killing several people. The 1816 bridge at Galashiels was destroyed by flooding in 1839, while the 1817 structure at Dryburgh and St Boswells in the Borders failed during high winds in 1818. Indeed, six of Britain's first seven suspension bridges and piers were destroyed before the end of the nineteenth century. Many other such bridges of the early to mid-1800s were replaced by new structures less liable to collapse and more able to carry the increasing weight of road traffic. So, had Captain Brown's vision of a Shields suspension bridge come to fruition and been successful in attracting traffic, it seems quite likely that it would have been replaced by a sturdier structure long before the present day.

The Union Bridge (1820) at Horncliffe (Northumberland) across the River Tweed and the Menai Bridge (1826) are the earliest British suspension bridges still to survive. The former carries minimal traffic and has been closed for repairs on a number of occasions. Although the latter is classified as an A road and carries a significant volume of traffic, it was substantially rebuilt in 1939 and the trunk route to Holyhead, for ships to Dublin, now uses the nearby, also rebuilt, Britannia Bridge of 1850. The historical significance of these bridges (both are Grade I-listed structures and minor tourist attractions) no doubt partly explains their continued existence. With this in mind, had the much larger Shields suspension bridge been built and survived into the twentieth century, it is feasible that it would have been maintained and repaired such that it would still exist as a protected structure today, most likely carrying pedestrians and some weight-restricted local traffic, while also being a significant feature on the

industrial archaeology tourist trail. Its role in the movement of traffic on Tyneside would be likely to be minimal, although many far less beneficial buildings and structures have come to fruition in North Shields since 1825.

TRANSPORTER BRIDGE

In 1901, a bill was introduced in Parliament incorporating the Shields Bridge Company with capital of £150,000 for the construction of a transporter bridge. The bridge was to be of the French-invented type similar to that which had recently been constructed in Portugalette, near Bilbao (1893), and in Rouen (1898). There were to be two steel lattice towers, sitting on the bed of the river 640 feet apart, with a height of 210 feet above high water. The towers would have been stayed by steel cables and between them a platform accommodating rail lines would have bridged the river at a height of 200 feet. 'Carriages' were to run on the rails from which thirty 140-feet-length cables would be suspended, supporting a 'car' around 40 feet above high water. The car was to be electrically powered and, carrying vehicles, pedestrians and potentially also trams, would have crossed the river in about ninety seconds. Approach roads to the bridge would have led from Howard Street in North Shields and from Mile End Road in South Shields.

The bill was opposed by the Tyne Commissioners, who argued that the bridge was unnecessary in view of the pedestrian and vehicle ferry services it operated between

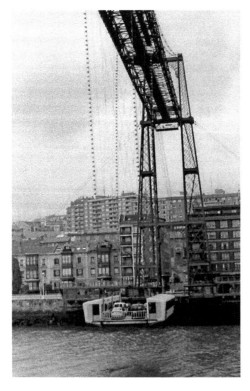

The 1901 transporter bridge scheme for the Tyne was to be of the same design as that constructed in 1893 at Portugalette, near Bilbao, Spain. This bridge still functions today. (Malcolm Rivett)

the two towns, which it intended to further improve. After several hearings in both the House of Lords and House of Commons the bill was rejected by a House of Commons committee on 3 July 1901.

Unlike some of the earlier and later bridge proposals, there is little doubt that a transporter bridge between North and South Shields would have been technically feasible. Indeed, in addition to those in France and Spain, one had already been constructed at Devil's Dyke, near Brighton, in 1894. Subsequently, three others were built in Britain, at Runcorn/Widnes (1905), Newport (1906), and Middlesbrough (1911). Such a bridge would have avoided the need for passengers and vehicles to climb the steep bank from the river to the town centre on the north side of the river. However, aside from that, it would arguably have offered few advantages over, and would have been less flexible than, the multi-route ferries.

The fortune of the four British transporter bridges that were constructed is a mixed one. The Devil's Dyke bridge was dismantled in 1909, although as primarily a means of entertainment at a down land beauty spot, it had little in common with North Shields. The Runcorn/Widnes bridge across the River Mersey was dismantled in 1961, following the construction of the immediately adjacent Queen Elizabeth road bridge. The demand

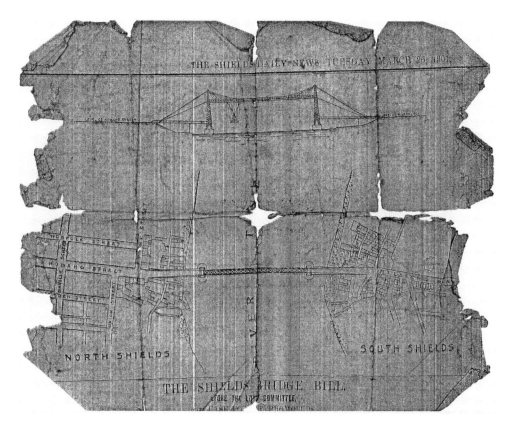

A (just) surviving scrap of the *Shields Daily News* of 26 March 1901 showing a plan and elevation of the proposed transporter bridge. (Author's Collection)

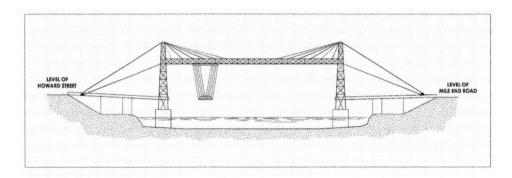

A modern facsimile elevation of the 1901 transporter bridge scheme. (Courtesy of Paul Gilmartin of pjgdesign.co.uk)

for vehicle movement across the Mersey at this point had clearly outgrown the limited capacity of the transporter bridge. Meanwhile, the bridges at Newport (River Taff) and Middlesbrough (River Tees) survive, although in both cases the reason for movement of people across the rivers at these points has largely disappeared as industry has changed. Thus, in the absence of the need for a higher capacity river crossing in these locations, the transporter bridges have survived as yet more curios of industrial architecture.

Had the Shields transporter bridge been constructed and demand for cross river movement at this point remained within its fairly limited capacity, it may well have survived until day, probably under frequent threat of closure as ever-increasing maintenance costs battled against public funding constraints. On the other hand, had the demand to travel between North and South Shields risen beyond the bridge's capacity, it is very likely that, as with the Runcorn/Widnes bridge, it would have been long since replaced by a road bridge. This conveniently brings us to the 1920s.

THE SPIRAL BRIDGE, THE DOUBLE SWING BRIDGE AND THE ERNEST JACKSON LIFTING BRIDGE

By the late 1920s motor vehicles had been around for a generation. While the level of private car ownership was still very low, growth in the volume of motor vehicle traffic had been enormous. Today's levels of car, van and lorry use could not have been envisaged but, nonetheless, there was increasing appetite for the development of national and local road infrastructure to cater for a further massive increase in motor vehicle use. The four-lane, steel, parabolic arch Tyne Bridge, between Newcastle and Gateshead, opened in October 1928 and a year later the similar, if somewhat more ungainly, Wearmouth Bridge at Sunderland opened. Both of these structures replaced ageing, lower capacity bridges but, no doubt, they provided inspiration to council members and officials in North and South Shields. Since 1849, North Shields, together with Tynemouth and the townships of Chirton, Preston and Cullercoats, had formed the borough of Tynemouth, also commonly referred to as Tynemouth Corporation.

THE ELEVATION PLAN OF THE SUGGESTED STRUCTURE.

The drawing shows that the bridge which the South Shields Borough Engineer favours has a length between the spiral approaches of 1,920 feet. The South Shields spiral would stand in the Mitre St that at North Shields behind the lower portion of Norfolk Street. The height above water, in the middle portion of the bridge, would be 185 feet above high water, ordinary spring tides.

The novel (or perhaps fantasy) 1929 bridge proposal of Mr J. Paton Watson, engineer for South Shields Corporation. Around sixty years later spiral ramps linking tunnels with a bridge were seriously considered as an alternative to the Channel Tunnel. (Courtesy of Johnston Press North East)

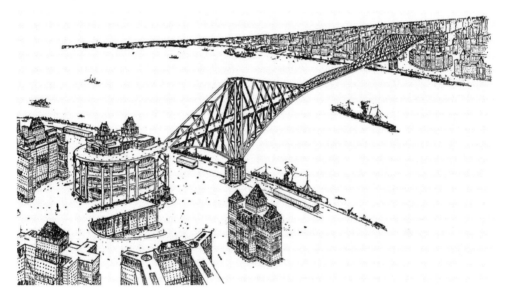

This artist's impression of Watson's bridge proposal illustrates the intention for the road ramps to spiral around buildings. A less pleasant building in which to live or work could hardly be imagined. (Courtesy of Johnston Press North East)

On 5 January 1929 the *Shields Daily News* reported that Mr J. Paton Watson, engineer for South Shields Corporation, was proposing a high-level bridge between North and South Shields. The £2-million scheme was described as a comprehensive project that would provide 185 feet clearance for ships. Notwithstanding the gorge in which the River Tyne flows between the two towns, the engineer had calculated that to achieve the necessary bridge height, with a maximum approach gradient of 1 in 25, the approach roads would need to extend inland some 3,800 feet on the south side and 1,900 feet at North Shields, effectively to Christ Church on Albion Road.

To avoid the expensive and disruptive property acquisition and clearance necessary to construct these approach roads, Mr Watson's novel solution (and this surely

underplays any reasonable meaning of 'novel') was spiral approach ramps. These would make four complete turns around newly constructed buildings. The briefest glance at the illustration of the bridge suggests that the claim 'one would scarcely realise having travelled the spirals before reaching the bridge' was, at best, fanciful. Perhaps tellingly, Mr Watson also stated that he was not aware of such a bridge having been constructed before.

Unsurprisingly little more was heard of Mr Watson's novelty, although other bridge proposals came forward thick and fast. Firstly, a Forth Bridge-like cantilever structure between West Percy Street in North Shields and Mile End Road on the south of the river was proposed by a South Shields haulage contractor, followed only a few days later on 28 January 1929 by a double swing bridge, the idea of Herbert W. Boyce.

This latter scheme, between Howard Street (North Shields) and Mile End Road (South Shields), would stand 90 feet above high water level. On what Mr Boyce considered would be the 'singularly few' occasions at which higher clearance was required, the two halves of the bridge would swing open, parallel to the river bank, in only sixty seconds, to provide a 600 feet width of unobstructed river. He also pointed out that, being only one-third of the height of other proposed bridge schemes, it would be a much less conspicuous target for enemy guns from the sea.

For those who have stood on the Newcastle Quayside looking up in awe at the Tyne Bridge soaring above them, imagine the same scene on Clive Street or the Fish Quay in North Shields with the bridge additionally moving at around 3 metres a second over one's head. It was admitted that there would be some inconvenience to road traffic when the bridge was open but as to the feasibility of, and power required for, moving a structure of this size nothing was said.

In 1929, Councillor R. Ernest Jackson published a pamphlet entitled 'A Shields Bridge', which recounted the history of the subject, considered the merits of a bridge versus a tunnel (the latter he considered would be more expensive and difficult to ventilate) and proposed another twist on the concept of a bridge between Howard Street and Mile End Road. With a gradient of 1 in 16, his bridge would rise from these points to give a clearance of 134 feet above high water level in the centre of the river. This, Councillor Jackson argued, would provide sufficient head room for all vessels except those carrying fixed topmasts and of the largest type. The central 200-feet section of the bridge would incorporate a Scherzer Roller-type double draw bridge to give the largest ships an extra 100 feet clearance. Countering the anticipated argument that a 1 in 16 gradient would be too steep, he reasonably pointed out that to reach North Shields town centre from the ferries, vehicles already had to negotiate Borough Road, which was almost twice as steep.

Councillor Jackson's pamphlet's conclusions on the matter, arguably a rallying call to fellow councillors and the Ministry of Transport, are worth recounting:

> The prosperity or otherwise of a town depends largely upon transport or easy communication with other towns and districts. The commerce of England is the result of the accessibility of its ports; in other words facilities for maritime transport. The Borough of Tynemouth is on the eve of very considerable commercial expansion.

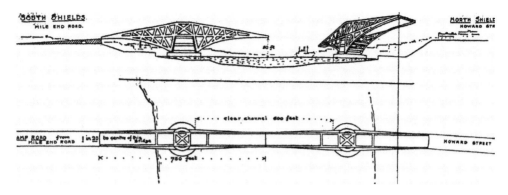

Herbert W. Boyce's double swing bridge scheme of 1929. Of lower height than the other bridge proposals of the period, it was argued that it would be a much less conspicuous target for enemy action. (Courtesy of Johnston Press North East)

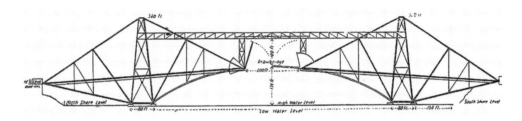

Councillor Ernest Jackson's contribution to the bevy of bridge proposals in the 1920s. Assuming a 75 per cent grant from the Ministry of Transport, Jackson calculated that a bridge toll of 2d per wheel for a period of fifty years would be sufficient to fund the scheme. (Author's collection)

At long last the Tyne Improvement Commission are beginning to realise that the really valuable part of the river lies at the mouth where there is already ample width and opportunities of securing depth. They have almost completed within the borough a work which will bring its measure of prosperity. I refer to the deep-water quay at Coble Dene Dock. Smiths Dock Co. Ltd are constructing a large new graving dock. We have extended and brought up to date our own Fish Quay, so that now very much better facilities are offered for the handling of fish, further the expansive front of quay now affords depth of water sufficient for vessels of larger type than the fishing craft. We do not doubt that this fact will be recognised and made use of in due course. Again we have not been unmindful of the attractions Tynemouth has to offer to holidaymakers. The recently constructed Bathing Pool at Tynemouth has proved a great attraction.

To reap the full advantage of all these activities we must have rapid and easy transport. We must be in a position to convey goods unshipped at the north side quickly and cheaply to the south side of the river. If we want to attract holiday makers from the densely populated parts of Durham we must offer a road through for their motor-cars and buses.

A glance at the road map of the North of England will reveal to the reader how very seriously road traffic on the North-East Coast is impeded by the break at the mouth of the Tyne and how very desirable a connecting link is at this point. There are five public bodies whose duty it is, in the interests of those they represent, to move in this matter, and that quickly. They are the Ministry of Transport, the Municipal Councils of Tynemouth and South Shields and the County Councils of Northumberland and Durham. The present-day increase of road transport demands it.

In 1931, the North Tyneside Joint Town Planning Committee published a report that proposed a large number of new and improved roads. This included the recommendation for a bridge spanning the Tyne between St Anthony's in Newcastle and Pelaw 'so as to connect the industrial areas of the Southern part of Northumberland and the Northern part of Durham and thereby divert through traffic from the congested areas of Newcastle upon Tyne and Gateshead'. In terms of a river crossing between St Anthony's and the sea, it merely mentioned that 'Conferences between the Local

The North Tyneside Regional Town Planning Scheme.

THE REPORT

—— OF ——

THE NORTH TYNESIDE JOINT TOWN

PLANNING COMMITTEE,

1931.

The North Tyneside Joint Town Planning Committee considered an area much wider than the modern-day North Tyneside, extending from the River Tyne at Prudhoe to the coast at Blyth and including the whole of Newcastle. (Author's collection)

Howard Street, North Shields, in 2017, the point from which most of the North Shields–South Shields bridge proposals would have spanned the river. Behind the flagpoles the land falls away steeply to the Tyne and the buildings in the background are on the other side of the river in South Shields. (Malcolm Rivett)

Authorities in this area have recently been held with regard to this proposed crossing, but the subject is only in its preliminary stage'.

The report's conclusions on the St Anthony's bridge were telling. Providing for through traffic was clearly fundamental to the justification of any expensive river crossing project and it made little sense for this to be routed through congested town and city centres. Thus, the death knell of a major road bridge or tunnel between North and South Shields was perhaps already sounding.

ROAD TUNNELS

In the mid to late 1930s various further joint committees and Tyneside local authorities met in an attempt to agree on the most suitable form and location of a river crossing downstream of Newcastle city centre. Most of the authorities (including Tynemouth) now supported a tunnel as the most practical option. However, unsurprisingly, each authority favoured a crossing in its own area. No doubt, urged on by Tynemouth and

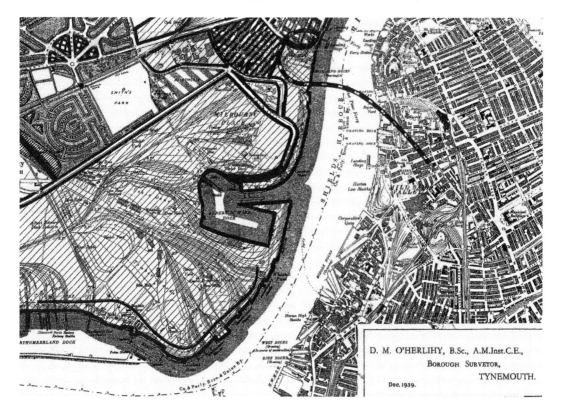

Tynemouth Corporation's December 1939 plans for a road tunnel between North and South Shields. (Author's collection)

South Shields Corporations, the Minister of Transport visited North and South Shields in November 1938, inspecting the ferries and considering the possibility of a tunnel between the two towns.

In December 1939, in the early days of the Second World War, D. M. O'Herlihy, the Tynemouth borough surveyor, published a plan denoting the alignment of a proposed road tunnel between New Quay (at the ferry landing) in North Shields and Chapter Row in South Shields. Demolition of the Northumberland Arms Hotel building would have been required to allow for the portal and to enable the tunnel to loop inland and then southwards back on itself in order to reach the necessary depth under the river.

In 1943, as Britain's fortunes in the Second World War began to rise and thoughts turned to post-war reconstruction, a government decision was made. Tunnels (for pedestrians/cyclists and motor vehicles) under the Tyne would be constructed between Jarrow and Howdon. Although in reality these would not open until 1951 and 1967, respectively, the die was cast: a Tyne road bridge or tunnel at North Shields was, for the foreseeable future, dead and buried.

But what if Tynemouth and South Shields Corporations had won the day in the 1920s and a major road bridge had been constructed between the two towns?

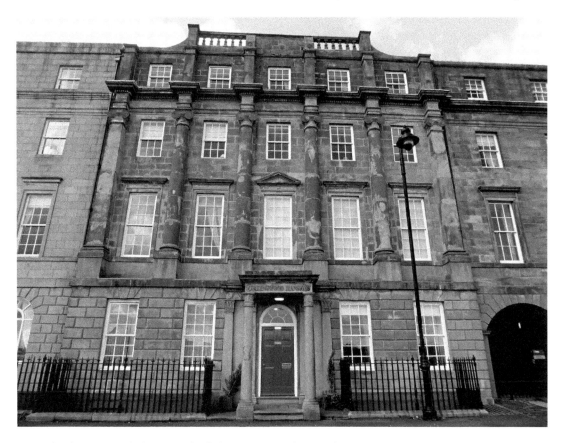

The location of the portal of the 1939 road tunnel proposal in 2017. The building, constructed in 1808, was originally the Northumberland Arms – a high-class hotel – but in later years, notoriously known as the Jungle, became a sailors' drinking den. Rundown and with soot-blackened stone in the late 1930s, its proposed demolition for the tunnel is perhaps understandable. The building has been listed since 1950 and today known as Collingwood Mansions, it comprises residential apartments. (Malcolm Rivett)

No doubt the bridge would have become an integral part of the A19 and almost certainly a case for building the existing Tyne road tunnels could not have been made. Ever-increasing volumes of traffic would have thundered through North and South Shields town centres to and from the bridge. The 1960s and 1970s would have probably seen major road construction work to separate through and local traffic in the town centres. The centre of Gateshead today, with its elevated roads and flyovers built in the 1960s to speedily funnel through traffic to the Tyne Bridge, gives us an idea of what might have been: a high-speed dual carriageway through the middle of Northumberland Square and Christ Church, standing forlorn, surrounded by a multilevel roundabout?

Those who today enjoy North Shields town centre as a relatively quietly trafficked cul-de-sac should perhaps be relieved that the road bridge and tunnel schemes of the 1920s and 1930s remain plans that never happened.

The River Tyne in 2017, without a bridge in sight. The nearest road crossings are the Tyne Tunnels, 3 miles upstream (behind the camera), and the Tyne Bridge, 10 miles or so away at Newcastle. (Malcolm Rivett)

Northumberland Square, North Shields, in 2017. The Georgian square lies on the direct line between Howard Street (from where the bridge schemes were to span the River Tyne) and the main A192 road to Morpeth and beyond. Would the square have been sacrificed to provide modern, high-capacity approach roads to the bridge? (Malcolm Rivett)

North Shields town centre today had one of the major road bridge schemes of the 1920s come to fruition? This is actually Gateshead town centre through which a series of flyovers were constructed in the 1960s to funnel traffic to the Tyne Bridge and onwards to Newcastle city centre. The absence of traffic is explained by the photographs being taken early on a Saturday morning. Gateshead Council now aspires to demolish the flyovers, the main stumbling block seemingly being money. (Malcolm Rivett)

TUBE RAILWAYS

Road bridges and tunnels were not the only cross-river schemes on the agenda during the twentieth century. In 1902, a passenger tube railway between Saville Street in North Shields and South Shields Station was authorised by Parliament, the project of a group of local businessmen. Deep lifts would have been required to access the trains and it is reported that the cost of these scuppered the scheme, despite a bill being promoted in 1906 to extend the powers enabling its construction.

In the early 1920s Tynemouth and South Shields Corporations became aware of the Kearney Tube system, which could operate on steep inclines of up to 1 in 7. According to its Australian inventor Elfric Wells Chalmers Kearney, its shallow stations would dispense with the need for lifts, making the project viable. The monorail, streamlined trains together with the steep downhill departure and uphill arrival would allow for high-speed, energy-efficient operation. In the early 1900s Kearney had unsuccessfully promoted similar schemes in London (between Cricklewood and the Oval and from the Strand to Crystal Palace) and also in New York and Boston. A surface level demonstration line between Brighton and Rottingdean, proposed in 1920, also came to nought.

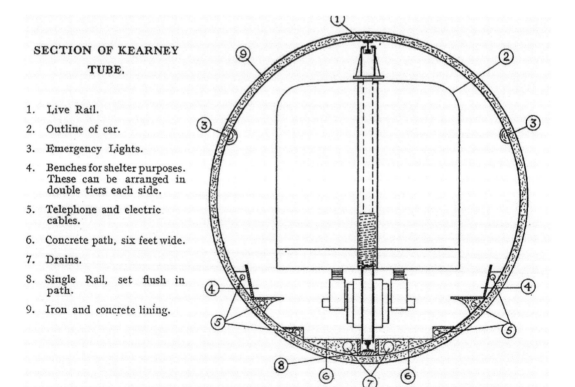

SECTION OF KEARNEY TUBE.

1. Live Rail.
2. Outline of car.
3. Emergency Lights.
4. Benches for shelter purposes. These can be arranged in double tiers each side.
5. Telephone and electric cables.
6. Concrete path, six feet wide.
7. Drains.
8. Single Rail, set flush in path.
9. Iron and concrete lining.

Basic engineering details of the Kearney monorail tube railway proposal. It was envisaged that the cars would carry pedestrians, cyclists and motorcyclists. (Author's collection)

On 22 December 1922 the Tynemouth town clerk wrote to Mr Kearney's solicitor advising 'with regard to the means of communications between North and South Shields, the Tynemouth Corporation are strongly in favour of improved communication between the two Harbour Boroughs by means of a tube and would be prepared to assist promoters of any scheme with this object in view'.

Kearney subsequently drew up plans for a tube over the shortest possible route – Howard Street to Palatine Street in South Shields. But, notwithstanding the town clerk's comments, a joint committee of the two councils resolved that any such scheme should provide both railway and road connection across the river. Kearney contended that such a scheme was practically and financially unviable. In 1925, an application for a Light Railway Order was made and in February and March 1926 a public inquiry into the scheme was held.

Tynemouth Corporation opposed the order and the Tyne Improvement Commission sought compensation in respect of the likely impact on the ferries. Otherwise, the scheme received widespread support, including from South Shields Corporation, many local people and, on an engineering basis, from Mr H. Pakenham Walsh, former chief engineer of India State Railways. In June 1926, the Minister of Transport announced the making of a provisional order and in 1928 the confirmation bill was passed unopposed, its first and second readings in Parliament. However, at the committee stage the bill was opposed with reference to Tynemouth Corporation's concerns about the lack of financial evidence to

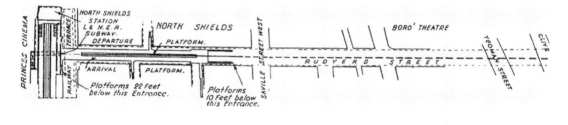

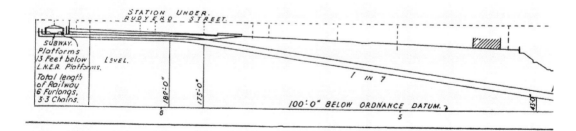

A plan and section of the proposed North Shields terminus of the Kearney tube railway. The tunnel would have run under Rudyerd Street with the platforms under the street's north end. Access would have been provided from North Shields railway station and from near Saville Street. The section belies the steepness of the tunnel gradient – 1 in 7 being necessary to get under the River Tyne. (Author's collection)

support the project and its failure to link the railway stations in North and South Shields. The bill was rejected.

Throughout the 1930s Kearney sought to persuade Tynemouth of the case for his tube scheme. Meanwhile, as we've already seen, the Corporation proposed but failed to get the support of neighbouring authorities or the Minister of Transport for its own road tunnel proposal. In 1939, undeterred by the past failures, Kearney once again sought to promote a Light Railway Order for the tube – this time running from beneath the platforms of North Shields railway station to the front yard of the station in South Shields.

A pamphlet demanding 'A SQUARE DEAL for the KEARNEY TUBE – NOW!' boasted that it would not cost either council a penny but would contribute to the rates and would be a customer for the Corporation's Electricity Department. The journey time would be one minute with a service every three minutes carrying bicycles and motorcycles as well as passengers. Unlike on the ferries, passengers would be protected from wind, rain, cold and fog and it would be easy for them to return home to either side of the river for a midday meal.

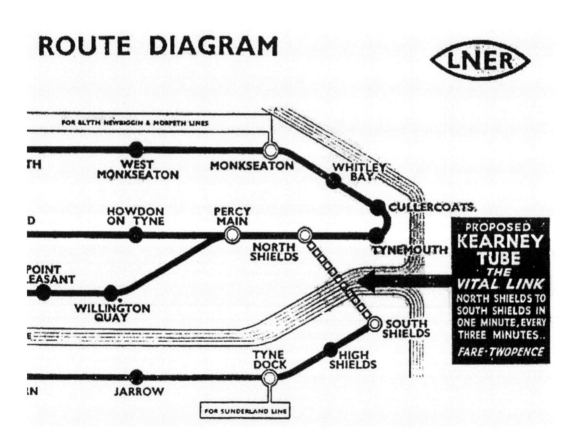

The 1939 'A SQUARE DEAL for the KEARNEY TUBE – NOW!' pamphlet included this map suggesting that the scheme could have been an integral part of the Tyneside electrified suburban rail system. (Author's collection)

TYNEMOUTH SURVEYOR'S SUPPORT FOR KEARNEY TUBE PLAN

Conversion Into Air Raid Shelter Stressed

Shields Evening News, 1939. (Courtesy of Johnston Press North East)

The scheme generated extensive column inches in the (South) *Shields Gazette* and (North) *Shields Evening News* and the support or opposition of engineering experts and numerous local worthies was reported in detail. Tynemouth Corporation appeared to have been won over by Kearney to at least not oppose the scheme, on the understanding it would not be a financial burden to its rate payers. But then in May 1939 South Shields Council resolved formal and emphatic opposition to the proposal, notwithstanding Alderman Chapman's comment 'I think the scheme would be more beneficial to South Shields than to Tynemouth, because we have more attractive shops'. South Shields had now adopted Tynemouth's original position that any tunnel should provide for road traffic. Meanwhile, as another war with Germany loomed, Kearney himself vaunted the scheme as being able to provide air-raid shelter accommodation in the form of double tiers of seats along either side of the tube.

On the basis of South Shields' objection, a Ministry of Transport public inquiry into the scheme was announced for 6 June 1939 but, seemingly, this was cancelled while Kearney attempted to negotiate with South Shields Corporation. September of that year brought the declaration of war with Germany and for everybody other than Kearney himself there were then more pressing things to consider.

Kearney tried to resurrect interest in the scheme in 1943 at which time some called for a local referendum on the matter, and then again in 1955 as the country was moving out of post-war austerity. But by then the focus of local and national government was very much on road infrastructure to provide for the rapid rise in car ownership. Elfric Kearney died in the 1960s (sources vary as to the precise date) and with him his revolutionary tube railway scheme.

That none of the many tube schemes proposed across the world by Kearney came to fruition suggests that, notwithstanding the vacillations of Tynemouth and South

Shields Corporations, a high-speed tube railway beneath the Tyne was never a realistic prospect. Indeed, Google 'Kearney' and the second link in the list is to the Science Fiction Encyclopaedia! But, very pleasant as it is to cross the Tyne by ferry on a warm summer's day, it cannot be denied that it would be fun to make the return trip by underground monorail, travelling at an average speed of 75 kph.

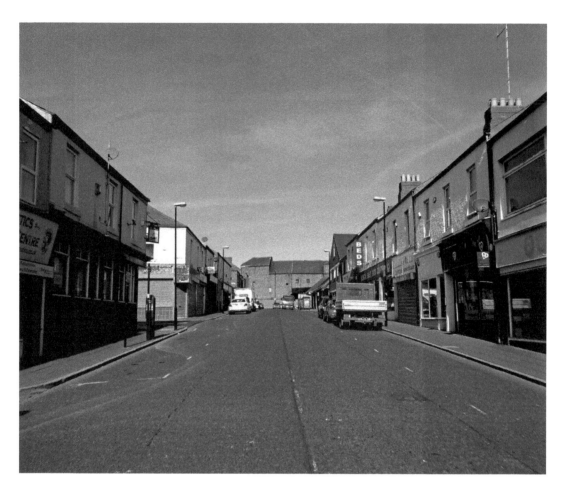

Rudyerd Street, North Shields, in 2017. The Kearney Tube tunnel would have been between 10 and 20 feet below this street. Access to the platform was to have been provided from both sides of the street, via steps from the pavement in the foreground of the photograph. (Malcolm Rivett)

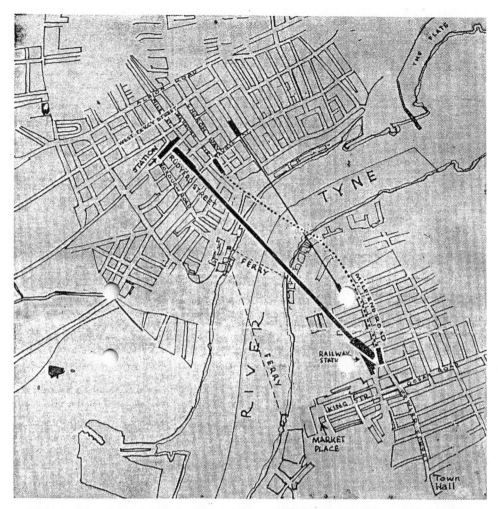

THREE tube schemes for linking up North and South Shields have been proposed since the beginning of the century. First, indicated on the map with a dotted line, was the project of a group of North Shields business men and was abandoned in 1905 on the grounds of expense.

Second scheme, shown by a thin black line, is the route followed by Mr Kearney's original tube railway proposal in 1925. Thick black line indicates the new and improved Kearney scheme which makes direct contact on both sides of the river with the L.N.E.R. stations and for which a Ministry order is now being sought.

Shields Evening News, 5 April 1939, showing the alignments of the three tube railways proposed since 1900. (Courtesy of Johnston Press North East)

Chapter Two

The Town Centre

The origin of North Shields lies in fishermen's cottages on the banks of the River Tyne. However, by the end of the nineteenth century the commercial heart of the town was, as it remains today, on the plateau high above the river and broadly bounded by Albion Street, Stephenson Street, Tyne Street, Borough Road and Sidney Street.

Town planning as we know it today came into being with the Town and Country Planning Act of 1947. However, an act of the same name of 1932 empowered local authorities to make schemes 'with respect to any land ... with the general object of controlling the development of the land comprised in the area to which the scheme applies, of securing proper sanitary conditions, amenity and convenience ... and generally of protecting existing amenities whether in urban or rural portions of the area'.

PROPOSALS FOR REPLANNING

Under the 1932 Act D. M. O'Herlihy, Tynemouth borough surveyor, published 'North Shields: A Survey of Existing Conditions and Some Proposals for Its Re-Planning and Redevelopment' in February 1939. The report included some thirty-odd numbered proposals with a particular focus on the town centre, and made clear at the outset the objective of suggesting improvements that would not mean a large increase in the rates. This aim, however well intentioned, would arguably dog North Shields town centre for the next forty years.

Proposals for a new civic centre were at the heart of the report for which it was stated there was a 'dire need', notwithstanding the existing, centrally located town hall of 1856. Estimated to cost £150,000, the report recognised that the council would be unlikely to ever vote for the necessary finances to construct the scheme, so Mr O'Herlihy proposed that it could be constructed in 'units' over time. The overall scheme would incorporate a town hall with a council chamber and committee rooms, municipal offices, a police station, a fire station and a library, museum and art gallery. The municipal offices would be on the south side of Saville Street bridging Howard Street and were to be topped by a tall clock tower. With reference to civic pride the report pointed out that the tower would be seen for miles on the south side of the river. Clearly the municipal offices were to be, in building form, a digit stuck up at South Shields Corporation whose fine town hall clock tower had been visible across the river

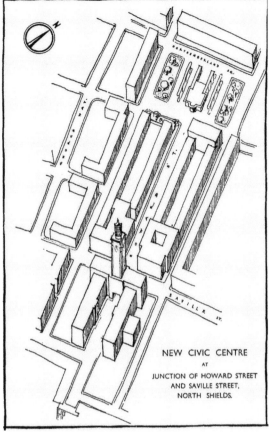

Above left: February 1939. (Author's collection)

Above right: The 1939 proposals for North Shields town centre were dominated by a town hall clock tower, not dissimilar from that actually built in Norwich in 1938. (Author's collection)

from North Shields town centre for thirty years. Eventual demolition of the 1856 town hall (now a listed building) was proposed on completion of the scheme.

The report envisaged Howard Street as a key axis in the town centre. At the north end of this street the central gardens of the Georgian period Northumberland Square would be redeveloped as an omnibus station with separate arrival and departure lanes and provision for waiting rooms, inquiry offices, shelters and public conveniences. The air raids of the Second World War are frequently blamed for the loss of historic features in many towns and cities, although this report shows that plans for their destruction were clearly in mind well before the first bombs landed.

Scheme No. 17 proposed 'better communication' for the southern section of Howard Street in the form of a viaduct from Union Street to Sibthorpe Street, along the alignment of Tiger Stairs and bridging Lower Bedford Street. The report stated that vehicles travelling from Borough Road to Union Street would, thus, be able to do so

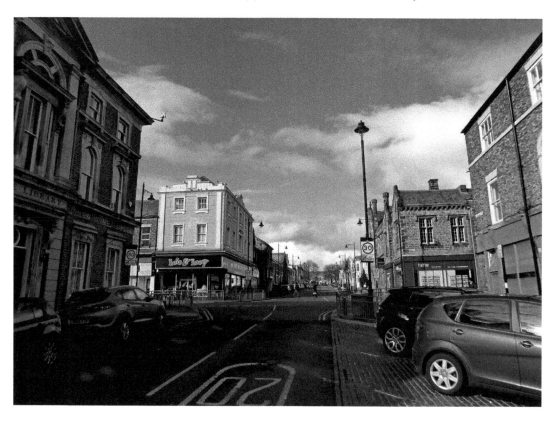

★ The Planning of Modern Buildings

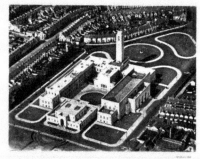

TOWN HALLS

By
A. CALVELEY COTTON
A.R.I.B.A.

Above: Howard Street in 2017, the site proposed in the 1930s for a civic centre and new town hall. On the left is the original public library, which was replaced in 1975 by the current library in Northumberland Square. On the right in the middle distance is the old town hall of 1856. (Malcolm Rivett)

Left: It seems likely that this 1936 document was on O'Herlihy's desk while he prepared his plans for North Shields. Town hall clock towers had been around since Georgian times and by the 1930s were taller and slimmer than ever before. In the austere post-war period there was little money for such follies. (Author's collection)

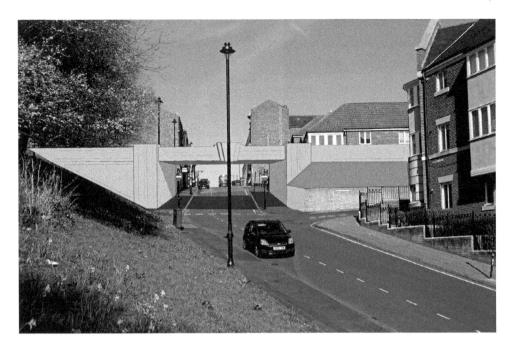

An indication of how the 1939 proposal for a bridge over Lower Bedford Street may have looked. It is difficult to imagine that the bridge's construction would have been justified by the minimal detour it would have saved vehicles having to make. (Courtesy of Paul Gilmartin of pjgdesign.co.uk)

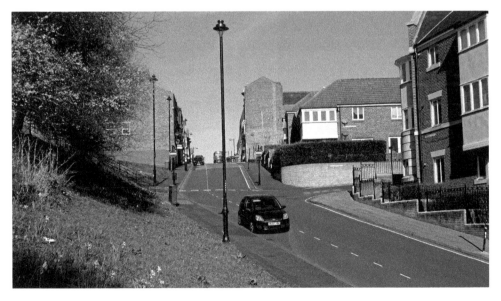

Lower Bedford Street in 2017, without the proposed bridge. This area of the town centre lay semi-derelict for many years after the Second World War while earmarked for a new civic centre. The housing on the right was constructed in the 1990s once the civic centre plans had been abandoned. (Malcolm Rivett)

without a 'long detour'. Given that the detour (via Saville Street) is around 200 metres long, this was arguably a solution to a problem that did not exist.

WIDER STREETS, OPEN SPACES AND TALL BLOCKS OF FLATS AND OFFICES

As with the cross-river schemes, the Second World War put pay to immediate implementation of any of the 1939 report's proposals. However, in the final years of the war, national and local attention turned to post-conflict reconstruction and focussed on the benefits of town planning.

In September 1942, town planning was the subject of one of the Army Bureau of Current Affairs' fortnightly pamphlets. The bureau had been set up in 1941 by William Emrys Williams to educate and raise morale among British service men and women. There was a particular focus on various aspects of post-war reconstruction, nationalisation and the welfare state. The pamphlet sought to summarise the problems that had been caused by an absence of town planning and the benefits that could result from it. A map of Great Britain was used to illustrate the problems and notably an arrow entitled 'squalor and disorder' pointed to Tyneside.

Sketches were used to deride the 'monotonous streets and sprawling suburbs' that characterised the country and promote the way forward with 'the pleasing grouping of buildings, trees and lawns'.

For town centres there were high-minded ambitions: 'The buildings and layout should have some of the fineness of conception that would reflect our belief in the worth of man. The heart of the city should no longer be a collection of unrelated buildings. It is a chance for the imaginative planning of tree-lined avenues, squares and colonnades, lofty buildings and terraces'.

Tynemouth 1849–1949, a publication celebrating a century of the existence of the borough, detailed the modern planning proposals for the area, which were said to be based on 'scientific knowledge'. Four main elements were envisaged: industrial estates, communications, neighbourhood residential units, and reconstruction of the town centre. In terms of the residential units, the creation of the Marden estate was envisaged and this was fairly quickly built, pretty much in accordance with the plan. Interestingly, however, this development was constructed much more along the lines of the sprawling suburbs derided by the current affairs pamphlet than the pleasing grouping of buildings, trees and lawns advocated by it.

The plans for the town centre better reflected the pamphlet. 'Wider streets, open spaces and tall blocks of flats and offices' were proposed, the Council arguing that 'Even the most loyal citizen must admit that this piece of planning, at any rate, is essential...' A model of the reconstructed town centre was built, detailing the various proposals including a roundabout at the junction of Preston Road and Albion Road and a wide new thoroughfare direct from this point to North Shields station, cutting diagonally across the existing street pattern. The shopping and business centre was to be remodelled. It would become more compact and the streets between the town centre

THE RESULTS OF FAILING TO PLAN IN THE PAST

Below is a map of Britain. We at once think of it as a green and pleasant land. Yet we have been rapidly spoiling this land with ugly unplanned building. Shall we let this happen again? The " Battle of Britain " was fought to save this country from spoliation by the Germans. After fighting for its preservation, shall we allow its beauty to be lost by thoughtless development?

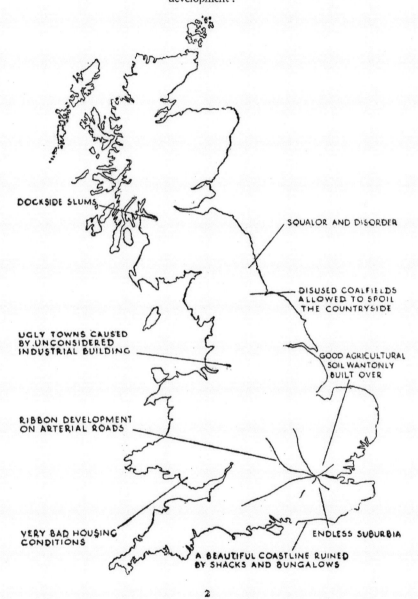

In the early 1940s the Army Bureau of Current Affairs issued fortnightly pamphlets on various aspects of post-war life. In the 26 September 1942 edition entitled 'Town Planning', a forthright view was presented on the results of failing to plan in the pre-war period. (Author's collection)

THE HOME IN THE TOWN.

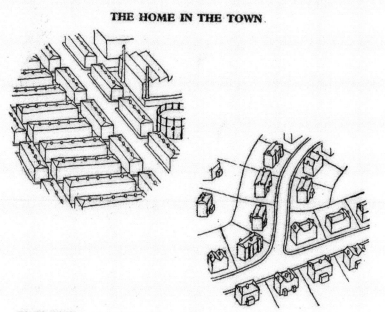

AS IT WAS—monotonous streets and sprawling suburbs.

AS IT MIGHT BE—the pleasant grouping of buildings, trees and lawns.

11

These sketches appeared in a section of the pamphlet titled 'How Planning Would Affect You'. In the late 1950s, multistorey flats similar to those pictured were constructed on the edge of North Shields town centre in the Stephenson Street, Tyne Street and Dockwray Square area, following slum clearance. Problems with their design, construction and maintenance meant they almost immediately became unpopular and they were demolished only twenty years later. (Author's collection)

and the river were to be reconstructed with blocks of flats overlooking a 'handsome stretch of green'.

As with the 1939 proposals a new bus station was to be constructed, although no longer at Northumberland Square, the central gardens of which were to be preserved, Hitler's bombs having spared them. Furthermore, while the concept of a civic centre remained, this was now to be located on Albion Road with a second elevation overlooking Northumberland Square. It is unclear as to whether the civic centre would have replaced the fine Georgian terrace on the north side of the square or if it would have just loomed above it from behind. That said, architectural consultant to the council was Charles H. Holden, the eminent architect who had designed for London Transport many of the, now much-celebrated, moderne-style Tube stations of the 1930s. So it is perhaps not entirely fanciful to think that the badly bombed North Shields railway station could have been reconstructed through this plan along the lines of Arnos Grove or Chiswick Park stations in London.

In the austere late 1940s and early 1950s, new housing and industry took priority over town centres and, thus, during this period virtually nothing of the council's plans for the reconstruction of North Shields town centre materialised.

To guide local authorities, and to supplement the 1947 Town Planning legislation, the Ministry of Town and Country Planning published an advisory handbook *The Redevelopment of Central Areas*. This detailed the problems faced in many town centres at the time: extensive war damage, outdated buildings with inadequate servicing facilities, streets not able to accommodate the vehicular traffic using them, and conflict between pedestrians, private vehicles and goods vehicles.

The handbook promoted the concept of the 'shopping block' whereby buildings and street layouts would be reconfigured to provide separate streets for public access to attractive shop frontages and rear access for servicing. With an eye to both financial constraints and the multiplicity of land and property owners in most town centres, the handbook detailed complex methods by which reconfiguration of town centres could take place in stages.

By 1960, more than a decade after its publication, minimal progress had been made with the North Shields town centre redevelopment scheme. In May of that year Solomon Caplan, chairman of the North Shields Chamber of Trade and Commerce, argued that the town centre could wait no longer for the council's scheme, which, anyway, 'causes so many of us so much concern'. Instead, he proposed allowing a property trust to redevelop a large part of the town centre on the 'precinct shopping system', providing pedestrian ways with all traffic excluded. With reference to the recently completed Arndale shopping precinct in Jarrow, the 27 May 1960 editorial of the *Shields Weekly News* threw its weight behind the Chamber's proposals, stating, with a thinly veiled swipe at Tynemouth Corporation, that 'the development should be carried out by experts with ample funds at their disposal'.

By February of the following year the borough surveyor reconfirmed his view that the town centre redevelopment should be based on a 'bold, pre-conceived plan',

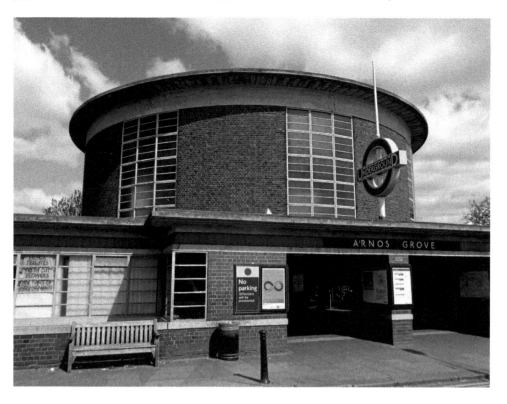

MINISTRY OF TOWN AND COUNTRY PLANNING

Advisory Handbook on

THE REDEVELOPMENT
OF CENTRAL AREAS

CROWN COPYRIGHT RESERVED

LONDON
HIS MAJESTY'S STATIONERY OFFICE
1947

Above: North Shields station as it might have been? This is Arnos Grove station on the London Underground Piccadilly line in 2017. Grade II* listed, it was designed by Charles H. Holden, architectural consultant to Tynemouth Corporation in the 1940s. (Malcolm Rivett)

Right: That there was a dedicated Ministry of Town and Country Planning demonstrated the importance attached to planning in the period immediately after the Second World War. (Author's collection)

THE LAYOUT OF STREET BLOCKS 65

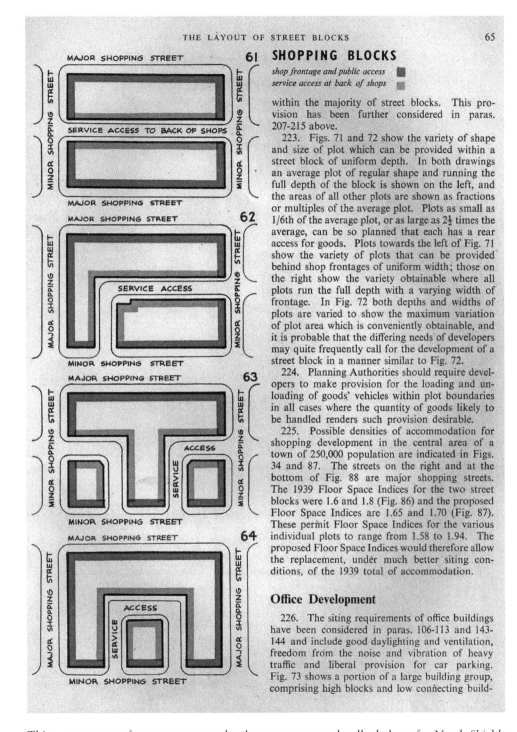

SHOPPING BLOCKS

■ *shop frontage and public access*
■ *service access at back of shops*

within the majority of street blocks. This provision has been further considered in paras. 207-215 above.

223. Figs. 71 and 72 show the variety of shape and size of plot which can be provided within a street block of uniform depth. In both drawings an average plot of regular shape and running the full depth of the block is shown on the left, and the areas of all other plots are shown as fractions or multiples of the average plot. Plots as small as 1/6th of the average plot, or as large as 2½ times the average, can be so planned that each has a rear access for goods. Plots towards the left of Fig. 71 show the variety of plots that can be provided behind shop frontages of uniform width; those on the right show the variety obtainable where all plots run the full depth with a varying width of frontage. In Fig. 72 both depths and widths of plots are varied to show the maximum variation of plot area which is conveniently obtainable, and it is probable that the differing needs of developers may quite frequently call for the development of a street block in a manner similar to Fig. 72.

224. Planning Authorities should require developers to make provision for the loading and unloading of goods' vehicles within plot boundaries in all cases where the quantity of goods likely to be handled renders such provision desirable.

225. Possible densities of accommodation for shopping development in the central area of a town of 250,000 population are indicated in Figs. 34 and 87. The streets on the right and at the bottom of Fig. 88 are major shopping streets. The 1939 Floor Space Indices for the two street blocks were 1.6 and 1.8 (Fig. 86) and the proposed Floor Space Indices are 1.65 and 1.70 (Fig. 87). These permit Floor Space Indices for the various individual plots to range from 1.58 to 1.94. The proposed Floor Space Indices would therefore allow the replacement, under much better siting conditions, of the 1939 total of accommodation.

Office Development

226. The siting requirements of office buildings have been considered in paras. 106-113 and 143-144 and include good daylighting and ventilation, freedom from the noise and vibration of heavy traffic and liberal provision for car parking. Fig. 73 shows a portion of a large building group, comprising high blocks and low connecting build-

This 1947 concept for town centre redevelopment was much talked about for North Shields but never implemented. However, the approach was employed in the reconstruction of a number of blitzed city centre shopping areas including Coventry, Plymouth and Bristol. (Author's collection)

although it was not stated whether this plan should be implemented by existing traders, the council, or a development corporation. Behind the scenes the problems appeared to be intractable: there was no realistic hope that action by individual small-scale traders would bring about the necessary transformation of the shopping area; the council was, as ever, reluctant to lead any scheme that might require an increase in the rates; and many traders (some of whom were also members of the council) feared that an Arndale-style property developer would charge rents they could not afford and would attract to the town centre unwelcome competition in the form of multiple stores.

HOW NOT TO BUILD A SHOPPING CENTRE

The summer of 1963 finally brought a scheme of sorts from Tynemouth Corporation. The council was reported to be considering redevelopment of the town centre in partnership with a development company. Pedestrianisation was the theme, with existing streets to be designated as either a pedestrian precinct or an internal traffic and service road. Apart from the idea of pedestranisation, the plan, to be carried out in stages up to 1983, harked back nearly two decades to the government handbook of 1947. Meanwhile, nearby Jarrow and Wallsend had entered the modern world constructing entirely new precinct shopping centres.

The council's latest scheme proposed the concentration of shops and offices in the area bound by Albion Road, Stephenson Street, Saville Street and Sidney Street/Rudyerd Street, and these streets would together form a central area ring road. Residential development and municipal buildings were proposed for the areas surrounding this core. While making sense in principle, opposition from the many existing stores outside the core area could be expected.

A large bus station was proposed on Church Way on the site of what is today Barclays Bank. Access to it was to be via Church Way, Howard Street and the south side of Northumberland Square. The western side of the new ring road would require the construction of a new bridge over North Shields station linking Sidney Street with Rudyerd Street, although there was little evidence to suggest that detailed work into the costs of this had been carried out. The Ministries of Transport and of Housing and Local Government expressed reservations about the western side of the ring road, which, in addition to the bridge over the station, would have required the demolition of the Gaumont Cinema. This still stands today as the Beach Bingo Club. The ministries suggested that, instead, serious consideration should be given to Coach Lane, with its existing bridge over the railway line, forming the western side of the ring road.

Progress in developing and implementing the plan was painfully slow and, meanwhile, the council refused permission for, and fought at appeal, a number of small-scale retail schemes which were deemed to be not in accordance with the broad thrust of its redevelopment proposals. This included an extension to Walkers (House

of Quality) Ltd's department store, which was located outside the plan's retail core. In April 1964, the *Weekly News* reported that at another public inquiry a representative of a company seeking to open a betting shop in Nile Street had stated that Tynemouth Council had shown themselves 'masters of the comparatively easy art of making plans, sketches and models, but prove themselves hopelessly inadequate at the more difficult task of putting these plans into operation'. Both of these planning appeals were lost by the council. Meanwhile, despite the appointment of a consultant to assist the Corporation, as far as traders and the public could see the redevelopment plan was no further forward.

In February 1966, the council's consultant Max B. Tetlow published a report on the redevelopment of the central area of North Shields, accompanied by an artist's impressions and another model illustrating the town centre of the future. Radical change rather than a facelift was said to be necessary.

The report envisaged the plan being implemented in three main phases over twenty years. Tall office blocks would be constructed on Howard Street at Northumberland Square and at Saville Street, the latter forming part of a civic centre, which was back on the site originally proposed for it by O'Herlihy in 1939. The first stage of development was proposed in the area between Bedford Street and Howard Street in which the council had already cleared a considerable number of buildings and the remaining properties were mostly in poor condition. The separation of pedestrians and vehicles was proposed and a north–south level pedestrian route through the middle of the town centre was envisaged including a bridge across Saville Street to the civic centre area. The report was given an almost immediate boost by North Shields Co-operative Society, which announced that it was keen to build a large new department store as part of the redevelopment, to replace its various existing premises dotted around the town centre. However, the council itself was divided over whether and how to take forward Tetlow's ideas. The long-standing debate over who should lead the redevelopment – the council, existing traders or an outside development company – was still to be resolved.

Finally, in May 1966, the council stated its intention to declare a Comprehensive Development Area, bounded by Northumberland Square, Howard Street, Saville Street, Rudyerd Street, Sidney Street and West Percy Street. This was broadly the area Tetlow had identified as the retail core of the town centre. Moreover, the involvement of a development company was said to be the only feasible way of implementing redevelopment.

A little over a year later, in July 1967, it was announced that the council intended to start formal negotiations on terms and conditions with Hammerson Property and Investment Trust Ltd, with a view to the company being selected to implement the redevelopment scheme. The company was involved in similar schemes in Bradford (£8 million), Aylesbury (£3 million), Stockport (£2.5 million) and Burnley (£1.5 million). The front page of the 21 July 1967 *Weekly News* included a photograph of the recently completed Aylesbury development, which boasted sixty-two shops, restaurants, an office block, a bus station, and covered and open markets.

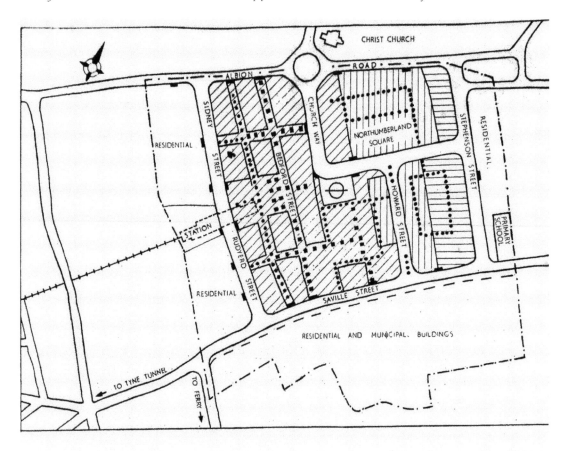

CENTRAL AREA REDEVELOPMENT. NORTH SHIELDS

Tynemouth Corporation's 1963 proposals for the redevelopment of North Shields town centre. The dot-dash line identifies the boundary of the area to be comprehensively redeveloped, within which there were to be separate zones for shopping (diagonal hatching), offices (vertical hatching) and industry (horizontal hatching). Proposed pedestrian precincts are shown by square dots and internal traffic and service roads by round dots. A bus station would sit at the heart of the town centre. (Courtesy of Johnston Press North East)

Thirty years on from the 1939 report on the town centre, progress with its redevelopment finally seemed to be getting underway. In December 1967, the council formally advertised its proposal to declare a Comprehensive Development Area to 'be developed as a whole for the purpose of dealing satisfactorily with conditions of bad layout and obsolete development', giving it powers to compulsorily purchase property to implement the scheme. Unsurprisingly objections were received, led by the North Shields Chamber of Trade and Commerce, and a five-day-long public inquiry was held in October 1968. This was described by the *Weekly News* as the biggest ever planning inquiry held in Tynemouth.

As a result of the inquiry the inspector appointed by the Secretary of State to consider the matter concluded that the proposed shopping area was too large, there was no evidence of need for the proposed offices, there was an absence of land designated for entertainment uses, and that it was unlikely that the site allocated for a bus station would be used as such. Nonetheless, two years on from the inquiry, the Minister of Housing and Local Government determined that the inspector's criticisms did not warrant rejection of the council's proposals. Thus, he confirmed the Comprehensive Development Area subject to some relatively minor modifications. The council was understandably delighted and it finally seemed likely that the long-awaited redevelopment would happen. In December 1970, Hammerson announced that they wished to start construction on phase one of the development in the middle of 1971.

In line with Hammerson's developments elsewhere, the envisaged scheme would be a pedestrianised precinct with overhanging canopies to protect shoppers from the weather. The plans for a level pedestrian walkway leading to a bridge over Saville Street were to be abandoned and instead the pedestrian precincts would follow the natural slope of Bedford Street. The scheme would incorporate two multistorey car parks.

All seemed to be going well until September 1971 when, in a shock announcement, Hammerson withdrew from the scheme, explaining that they had had great difficulty in securing general support for the proposal and, in particular, had been unable to attract a large chain store to the development on which its success would depend. Somewhat surprisingly Tynemouth Corporation held its nerve and immediately sought expressions of interest from alternative development companies. Less than two months

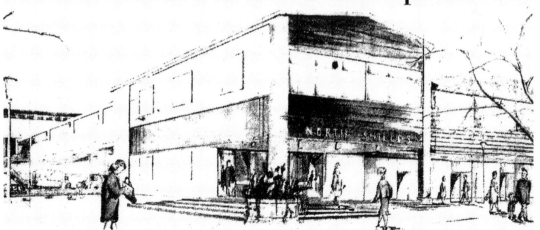

An artist looks at the plan...

this the North Shields Railway Station of the future? It could well be in this artist's impression of how the station could

A reconstructed North Shields station as proposed by the 1963 redevelopment plan. (Courtesy of Johnston Press North East)

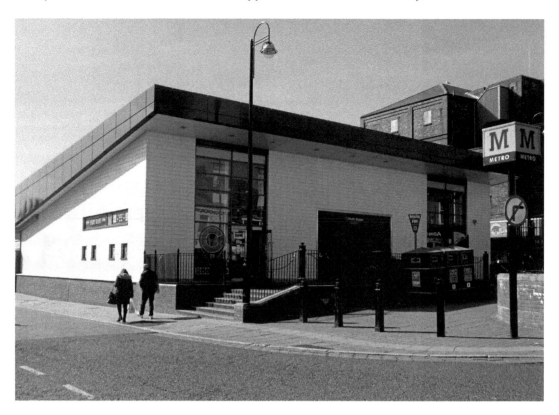

North Shields metro station in 2017. This is the sixth station building on the site. The initial minimal and largely wooden facilities of 1839 were replaced in 1843 by permanent, but still modest, station buildings. In 1890, a considerably more substantial affair was opened, among great celebration. Incorporated into this station were a large entrance portico and a glazed overall roof. Badly damaged in the Blitz, the overall roof and main buildings were demolished in 1966, replaced with street-level accommodation amounting to little more than a Portakabin. More substantial station facilities were opened in 1982 with the conversion of the line to metro operation, this building surviving only to 2012 when it was replaced by the current structure. Proposals for a recreation of the glazed overall roof, as part of the 2012 redevelopment, did not come to fruition. (Malcolm Rivett)

on from Hammerson's withdrawal this was forthcoming in the form of Town and City Properties Ltd, more familiarly known as Arndale.

Arndale proposed 'a completely new concept in shopping for the town centre' consisting of a huge indoor arcade with spacious pedestrian malls and a wide variety of shops, murals, fountains and novelty features – all designed as 'an attempt to stimulate the senses'. Immediately members of the council's Town Improvement Committee set off to visit Arndale's recently completed schemes at Leeds, Middleton, Stretford, Bolton and Nelson.

The detailed plans now showed a massive indoor shopping centre stretching from Northumberland Square to North Shields station and as far as Saville Street in the south. The streets within this area, including Bedford Street, would disappear, and a

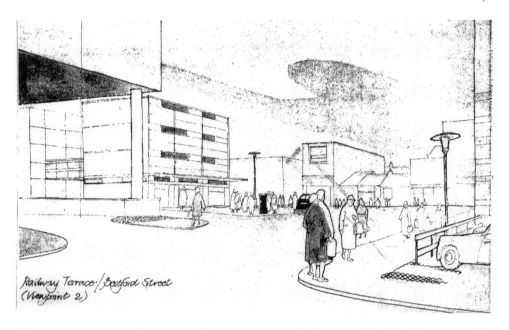

The 1963 plan envisaged an open pedestrian square at the front of North Shields station. This artist's impression is looking from the station towards Bedford Street. (Courtesy of Johnston Press North East)

The view from the station towards Bedford Street in 2017 showing, still in place, the block of small shops proposed for demolition under the 1963 plan to make way for a pedestrian square. (Malcolm Rivett)

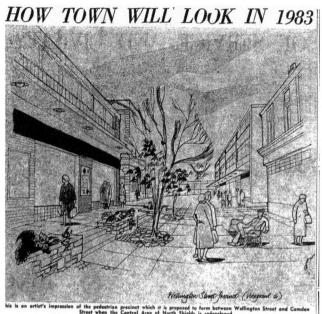

HOW TOWN WILL LOOK IN 1983

This is an artist's impression of the pedestrian precinct which it is proposed to form between Wellington Street and Camden Street when the Central Area of North Shields is redeveloped.

Left: Wellington Street, looking towards Bedford Street. The 1963 plan was to be implemented over a twenty-year period. The artist clearly did not envisage that the wearing of hats by almost everyone would be a thing of the past by 1983. (Courtesy of Johnston Press North East)

Below: How the town looks in 2017. Wellington Street is not as a pedestrian precinct as envisaged in 1963. Phases one and two of the eventual town centre redevelopment scheme are to the centre (background) and left (foreground). (Malcolm Rivett)

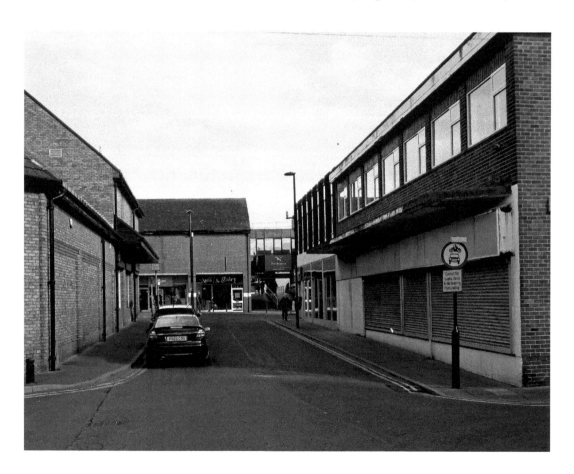

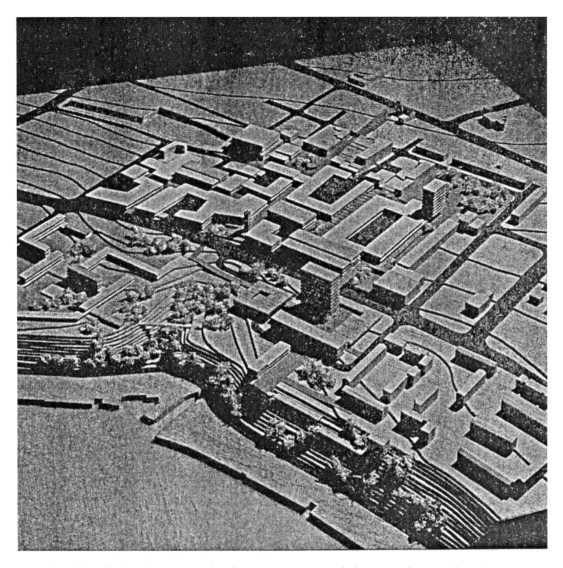

The relatively low-key proposals of 1963 were superseded in 1966 by consultant Max B. Tetlow's radical plans, a scale model of which was unveiled. (Author's collection)

central square would be sited broadly where Burger King and Superdrug are located today. From this square, air-conditioned, covered shopping malls would extend in each direction and a pedestrian bridge over Saville Street was back on the cards. The development would provide seven large stores and around ninety smaller ones. Marks & Spencer, Tesco and Woolworths were all said to be interested in being involved in the scheme. There would also be a market hall, pub, restaurant, social club and a new post office. Servicing would take place from behind and under the shopping centre, taking advantage of the slope across the site, and parking for 1,500 cars in total would be provided on upper levels. It would be four storeys in height at Saville

PUBLIC ANNOUNCEMENTS

PUBLIC NOTICES

TOWN AND COUNTRY PLANNING ACT 1962
COUNTY BOROUGH OF TYNEMOUTH
DEVELOPMENT PLAN
AMENDMENT No. 4 (1967)
COMPREHENSIVE DEVELOPMENT AREA No. 2
NORTH SHIELDS CENTRAL AREA

NOTICE IS HEREBY GIVEN that proposals for alterations or additions to the above development plan were on the 4th day of December, 1967, submitted to the Minister of Housing and Local Government

The proposals comprise (a) the definition of an Area of Comperhensive Development which in the opinion of the local planning authority should be developed as a whole for the purpose of dealing satisfactorily with conditions of bad layout and obsolete development and (b) the designation of the majority of the properties within the area as subject to compulsory acquisition for the purpose of securing its use in the manner proposed. and relate to the central area of North Shields bounded broadly on the north by West Percy Street and Northumberland Place; on the east by Northumberland Square, the back lane to the east of Camden Street and Howard Street; on the south by Saville Street; and on the west by Rudyerd Street and Sidney Street.

A certified copy of the proposals as submitted has been deposited for public inspection at the Town Clerk's Office, 14 Northumberland Square, North Shields.

A copy of the proposals is available for inspection free of charge by all persons interested at the place mentioned above between 9.0 a.m. and 5.0 p.m. on Mondays—Thursdays and between 9.0 a.m. and 4.30 p.m. on Fridays.

Any objections or representations with reference to the proposals may be sent in writing to the Secretary, Ministry of Housing and Local Government, Whitehall, London, S.W.1, before the 17th day of January, 1968, and any such objection or representation should state the grounds on which it is made and identify the land to which it relates. Persons making an objection or representation may register their names and addresses with the Tynemouth County Borough Council and will then be entitled to receive notice of any amendment of the development plan made as a result of the proposals.

DATED this 5th day of December, 1967.

FRED. G. EGNER,
Town Clerk.

Town Clerk's Office,
14 Northumberland Square,
North Shields.

December 1967 public notice of the proposal to designate a Comprehensive Development Area for the redevelopment of North Shields town centre. (Courtesy of Johnston Press North East)

Street but only two on the northern side near Northumberland Square, where it would adjoin the new library proposed by the council. The scheme was to be implemented in two phases, the first expected to be completed in October 1975.

The Council and Town and City Properties spoke very positively of the proposals. But since Hammerson, with a good number of shopping centres under its belt, could not make a scheme work in North Shields, many people may have wondered how Arndale would bring to fruition an even larger and more expensive development.

In working up the scheme, Arndale argued that a piece of land between Wellington Street and Saville Street (today occupied by Frank's carpet shop), not included in the confirmed Compulsory Purchase Order, was essential to the development. The council immediately set in train the promotion of the necessary order and in December 1972 a planning application for the scheme was submitted. The estimated cost for the two phases was between £5 million and £7 million (£60–85 million in today's prices) and construction work was expected to start in September 1973.

September 1973 came and went and then central government once again got involved, ministerial approval being required for the additional Compulsory Purchase Order. Worryingly for the council the new Department of Environment was also expressing concern over the size of the development and its potential to attract trade away from other town centres, including Wallsend and Whitley Bay. Months of negotiations followed and in return for the council agreeing to abandon statutory powers for the second phase of the development, the necessary ministerial approval for the first phase was granted in late March 1974. This was just a few days before the abolition of Tynemouth Corporation and the absorption of North Shields and Tynemouth into the new North Tyneside Metropolitan Borough Council. Three years on from the Hammerson development being ready to start on site, Arndale was now similarly poised. 1 July 1974 was the mooted date for the commencement of construction.

The early 1970s were a period of rampant inflation and it would have been a surprise to few that in June 1974 the £5–£7 million estimate of just a few years earlier for both phases of the Arndale scheme had risen to £10 million for the single phase now proposed. Worse, Town and City Properties Ltd announced that they were forced to delay the scheme because the money to finance it was not available. The council immediately stopped property demolition works, which had been ongoing for several years as a precursor to the start of development. Even so, arguably, the town centre now looked far worse than it had after the air raids of the Second World War. Some progress was made, however, with the opening in February 1975 of the new central library at Northumberland Square. An editorial of the *Weekly News* described this as 'a fine, imposing prestige building of which North Tyneside's ratepayers can be justly proud' but also as 'an oasis in a desert of wasteland'.

As its predecessor had done in 1971, North Tyneside Council now touted the development in an attempt to attract other developers to take on the scheme, while at the same time saying that Arndale had not been given the sack. A year later, in February 1976, it was announced that Project Management Consultants (PMC) had been appointed by the Council to carry out a revised scheme. Unlike Arndale, PMC was not a household name, but it had local connections – its chairman Ted Nancarrow being a resident of Tynemouth.

Stretford Arndale Centre. It was suggested that Arndale's plan for North Shields would have been similar. (Courtesy of Dave Crocker under Creative Commons 2.0)

The PMC proposal was to extend the whole length of Bedford Street from West Percy Street to Saville Street. In addition to 250,000 square feet of supermarkets, department stores and other shop units, the scheme would include a ten-storey office block, a fifty-bedroom three-star hotel, sixty private apartments, a cinema, pubs, clubs and a two-deck underground car park for 500 vehicles. Mr Nancarrow said that it could make North Shields 'the Chelsea of the North'. Even the least sceptical of people may well have raised an eyebrow at this comment, given that Hammerson and Arndale, leading town centre development companies, had failed to make North Shields the Aylesbury or even the Stretford of the north.

In January 1977, no doubt to the surprise of many, a contract was signed with the council to deliver the first phase of this development, comprising 200,000 square feet of shops, a covered mall and a car park. The other facilities, including the hotel, would form part of a second phase. At this stage the financial backer for the scheme was not announced, but emerged later in the year as being the National Union of Miners (NUM) Pension Fund. It was surely not a coincidence that the leader of North Tyneside

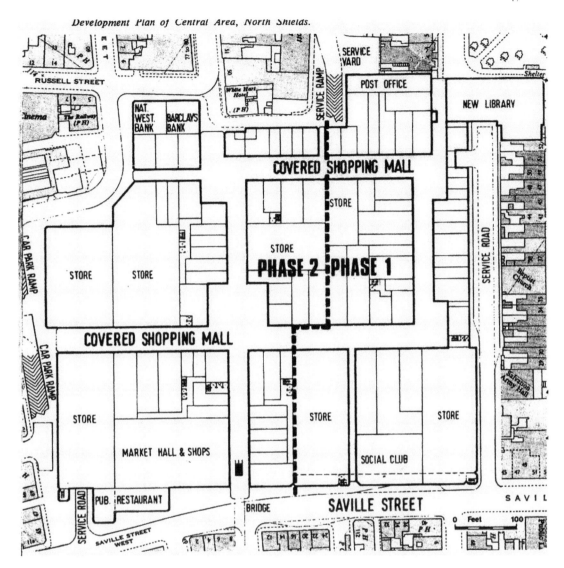

Development Plan of Central Area, North Shields.

Arndale's plans for North Shields town centre. The existing streets and buildings between the station, Northumberland Square and Saville Street would have been completely demolished and replaced by a massive indoor shopping precinct. (Author's collection)

Council Jim Bamborough was a friend of the NUM president Joe Gormley. Even more surprisingly, construction work started almost immediately and what we today know as the Beacon Centre, originally named the Bedford Centre, opened on 5 December 1978. It had taken almost forty years from O'Herlihy's plan of 1939 for redevelopment of one relatively small part of North Shields town centre to take place. And even the eventual opening ceremony of that was a damp squib, with snow preventing Sir Derek Ezra, the chairman of the National Coal Board, from arriving in time to formally open the centre.

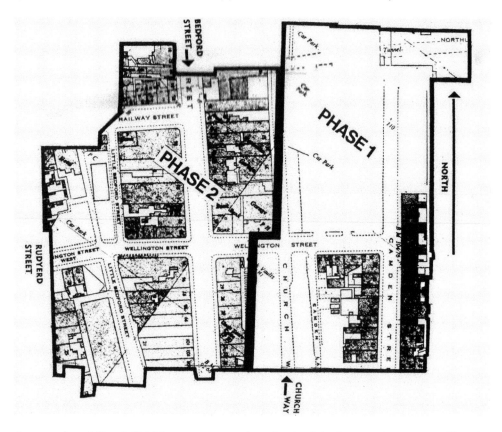

A 1973 plan of North Shields town centre when the Arndale Centre scheme was still in the offing. The decimation of the town centre through property clearance, in anticipation of the redevelopment, can clearly be seen. (Courtesy of Johnston Press North East)

Nevertheless, the scheme was successful in attracting two big supermarkets to North Shields (regional operators Presto and Hintons) and a Littlewoods department store. The rest of the centre was mostly occupied by smaller chain stores, some new to North Shields and other transferring from elsewhere in the town centre. As predicted some fifteen years previously, few local traders secured premises in the centre. Nearly forty years on from its opening only four of the original occupiers of the centre are still present – Boots, Greggs, Barclays Bank and the Yorkshire Building Society (formerly the Huddersfield Building Society). Another original occupant, the NatWest Bank, closed its doors for the last time in June 2017.

Thoughts almost immediately turned to the second phase. Instead of providing a hotel, apartments and leisure facilities in the area between the new centre and West Percy Street as originally planned, this was now to involve more retail units on the land to the west of Bedford Street. Work started in September 1981 and the main part of the scheme – a Co-op department store, consolidating the firm's various shops around the town centre into one building – was ceremoniously opened by TV impressionist Janet Brown a year later. While redevelopment had now been completed in around

two-thirds of the area proposed for the ill-fated Arndale scheme, the outcome was very different from that originally envisaged. The two shopping developments were not connected either architecturally or physically and the still heavily trafficked Bedford Street separated the two. Pedestrianisation of this street would not take place until October 1989. Furthermore, only shops had been built and the proposed pubs, clubs, cinema and hotel had not materialised, nor was it likely that they would do so in the foreseeable future.

In 1995, the council and regeneration agency North Tyneside City Challenge secured £10.7 million government funding to invest in enhancing the town centre. As a result, improvements to the forecourt of the metro station and to the public realm of Howard Street were implemented. However, one proposal that did not see the light of day was a row of outdoor market stalls on land at the junction of Bedford Street and Saville Street, cleared of buildings many years earlier to facilitate the abandoned widening of Saville Street.

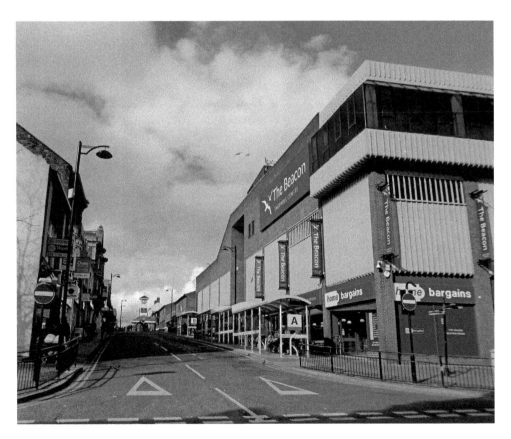

Bedford Street at its junction with Saville Street in 2017, with phase one of the town centre redevelopment, as constructed, on the right. Is this the Chelsea of the north promised by its developer? The failed Arndale scheme of the early 1970s would have spanned both sides of Bedford Street with indoor shopping malls. Pedestrians would have crossed Saville Street to the point from where the photograph was taken on a high-level bridge. (Malcolm Rivett)

Since the 1939 plan a new civic centre had been a key part of the town centre redevelopment proposals. In 1982, the council's 'North Shields Central Area Local Plan' proposed the area south of Saville Street, between Lower Bedford Street and Howard Street, for office development. A civic centre here, set in parkland overlooking the river, was mooted, aping O'Herlihy's and Tetlow's proposals of the 1930s and 1960s. After all, the new Northumberland County Hall in Morpeth had recently opened and plans were well advanced for a new civic centre in Gateshead. So why not the same for North Tyneside? But the 1980s were hard financial times for local government and, anyway, did it make sense to locate a civic centre in the far south-east corner of the now much bigger borough? Unsurprisingly nothing happened and the council was administered from various offices scattered around the borough until 2008 when most services were transferred to the Quadrant Town Hall and Civic Hub at Cobalt Business Park. While this is fairly central to the borough as a whole, it is notably not in any of its town centres.

The west side of Bedford Street in 2017. This would have been demolished to make way for phase two of the Arndale shopping centre scheme. Lack of money and concern about the impact of a scheme of this size on Wallsend and Whitley Bay town centres put pay to redevelopment of this part of North Shields town centre. (Malcolm Rivett)

One of a number of town centre enhancement schemes proposed in 1995. This site at the corner of Bedford Street and Saville Street was cleared for the widening of Saville Street – yet another plan that didn't happen. (Courtesy of Johnston Press North East)

The junction of Bedford Street and Saville Street in 2017. Trees, planters and a seat occupy the site rather than the market stalls proposed in 1995. (Malcolm Rivett)

The North Shields Central Area
Local Plan of 1982 restated the
long-standing intention to develop a
civic centre on land between Lower
Bedford Street, Saville Street and
Howard Street. In the 1990s this
area was finally redeveloped for a
mix of uses including housing, offices
and a Job Centre.
(Author's collection)

North Shields town centre today is a far cry from the comprehensively redeveloped
commercial and administrative heart of a freestanding county borough that was
envisaged by O'Herlihy in 1939 and Tetlow in 1966. In many ways this is probably
a good thing – imagine the traffic, and could the massive Arndale scheme of 1971
have survived the onslaught of out of town supermarkets and Silverlink Retail Park?
Nonetheless, and maybe it is the planner in me, but I remain an admirer of 1960s/70s
redevelopment schemes when, in the rarest of cases, they were built and have been
maintained to a high standard. Studying the photograph of Tetlow's model, with its

Barbican Centre, City of London, in 2017 – fantasy of what could have been for North Shields town centre. (Malcolm Rivett)

tower blocks and landscaped parkland, I like to imagine that scheme fully implemented. North Shields as the London Barbican Centre of the north, with the added attraction of a spectacular riverside setting. A fantasy? Of course it is.

THE ALBION ROAD DUAL CARRIAGEWAY DEBACLE

While plans for redeveloping the town centre alternately progressed and stalled during the 1960s and early 1970s, proposals were simultaneously being developed to provide the road capacity forecast to be necessary to funnel the increasing numbers of car owners to the envisaged multistorey car parks. The 'improvement' of Albion Road was seen as essential, creating a dual carriageway from the Chirton roundabout at Billy Mill Lane/Wallsend Road to the junction of Tynemouth Road and Stephenson Street, near the present day Magistrates' Court.

By October 1968 the council's Town Improvement Committee had settled on the details of the scheme. From the roundabout the new road would be diverted away

from Chirton Green via Carlton Terrace and The Nook, involving the demolition of several shops and houses. The Nook was, and still is, an unusually wide road, originally being the alignment of a mineral railway line from Billy Mill Colliery. The new alignment would rejoin the old near the junction of Hawkey's Lane and Spence Terrace. Albion Road West and Albion Road would then be widened to a dual carriageway as far as the Stephenson Street junction. This would involve the demolition of four more houses and what is today the Tynemouth Motor Co. car showroom. Junctions along the new dual carriageway would be limited to Hawkey's Lane, Coach Lane, Sidney Street and Preston Road/Church Way. There would be minor alterations to other roads in the area to provide access to the streets no longer with direct access to/from Albion Road. It was envisaged that the improvement scheme, which was to receive a 75 per cent grant from the Ministry of Transport, would be carried out in three phases.

Councillor G. M. M. Bilclough, chairman of the Town Improvement Committee, was reported in the *Weekly News* as saying 'I think this is a wonderful scheme'. However, others in the council were far from convinced and believed that, despite the intention to construct up to four pedestrian subways under the road, the dual carriageway would be a racing track that would cut off the residential areas of the town from the shopping area. Only a month or so after the Town Improvement Committee had approved the scheme, the General Purposes Committee resolved that the former should reconsider the plans.

A year passed and a slightly tweaked scheme was brought back for consideration by the General Purposes Committee in September 1969. Still unconvinced by the proposal, the committee resolved to defer a decision on it until there was more certainty over the redevelopment of the town centre; the designation of the Comprehensive Development Area was at the time in the tray of the Minister of Housing and Local Government.

Ministerial approval for the Comprehensive Development Area eventually came in 1971 and with it the supporters of the Albion Road scheme in the council got their way. The formal process for compulsorily acquiring the land and property needed to build the road was quickly set in motion. Ten objections, including a petition signed by 600 people, were received and a public inquiry was arranged to be held in April 1972, conducted by Inspector W. G. Onslow. This would be the second large public inquiry concerning North Shields town centre within four years.

Many detailed objections were advanced at the inquiry but the three main ones were that a dual carriageway wasn't needed, it would result in speeding, and it would sever the town centre from the surrounding residential areas. Although there were dissenting members, the official line of the council was that the scheme was required to cope with the forecasted increase in traffic and that crossing the dual carriageway through its pedestrian subways would be safer than traversing the unimproved road.

The minister's decision came relatively quickly, in August 1972. While accepting that some improvement of Albion Road was necessary, he rejected the Compulsory Purchase Order that the council needed to build the dual carriageway. The formal

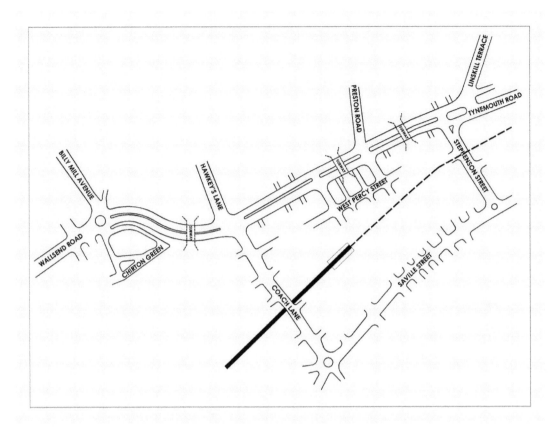

The Albion Road dual carriageway proposal. Note the pedestrian subways, about which there was so much controversy. (Courtesy of Paul Gilmartin of pjgdesign.co.uk)

letter to the council from the regional controller (Roads and Transportation) Northern Region explained:

> The Secretary of State accepts the need for an improvement of Albion Road to enable it to carry out its varied function ... Whilst such improvement may necessitate construction in whole or in part, to dual carriageway standard, he does not consider that a sufficient case on traffic grounds has yet been made to demonstrate the type and scale of the improvement proposed. He is therefore unable to accept the proposals now submitted.

For both the council and objectors to the scheme the minister's decision merely muddied the waters. Within six months the borough surveyor Alan Heatley put a revised scheme before the council. A dual carriageway was still proposed, supported by more comprehensive traffic forecast data, and there were minor adjustments to the design at the Chirton roundabout and Spence Terrace to reduce the amount of land and property needed. Meanwhile, those within the council who opposed to the scheme

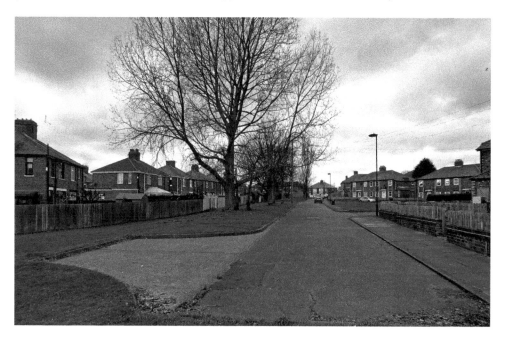

The Nook in 2017, which would have formed part of the dual carriageway and left Chirton Green as a cul-de-sac. (Malcolm Rivett)

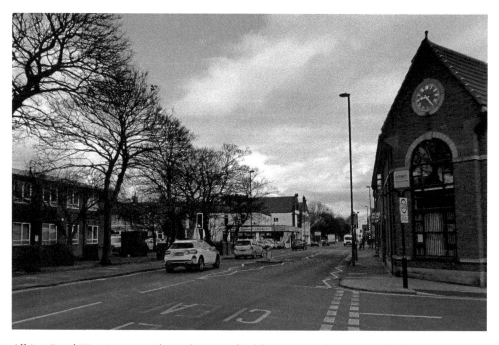

Albion Road West in 2017. The early 1960s health centre on the left was deliberately set back from the main building line to enable the road to be widened to a dual carriageway. However, the car showroom in the middle of the photograph (a garage in the 1960s) would have been a casualty of the scheme. (Malcolm Rivett)

This 1946 Ministry of Transport guidance document, reprinted in 1957, promoted dual carriageways through urban areas. (Author's collection)

Government guidance advocated subways to separate pedestrians from traffic. Many were built across the country as part of major road improvement schemes, although the idea, presented here, that they could be incorporated into existing urban streets was arguably fanciful. (Author's collection)

had once again gained the upper hand and even the supporters of it may have felt the amended design was insufficiently different from the previous proposal to be likely to secure ministerial approval. In March 1973 the General Purposes Committee threw out the revised plan by twenty-five votes to five.

Whatever the technical merits of the dual carriageway scheme, it was money that ultimately counted. In June 1973, as the economy began to falter, the government

Means of crossing otherwise than at surface level

341. The use of a bridge or subway for pedestrians eliminates all the risks attendant on crossing on the surface ; but where the need for them is greatest, *i.e.*, in fully-built-up areas, constructional difficulties are at a maximum, and in the main their provision must be confined to major intersections. As we have pointed out in para. 105, there is noticeable objection to making use of a subway or footbridge, probably because of the additional physical effort which is involved. The provision of ramped approaches instead of stairways will go some way to meet this reluctance, and will facilitate their use by perambulators and other hand-propelled vehicles. (Plate 25.) Objections are also raised to the use of subways which serve as a means of access to public conveniences, but this is surely carrying feelings of delicacy too far. In the absence of physical means to prevent surface crossing in the vicinity it is unlikely that either subways or footbridges will be largely used, and consideration should be given to the erection of barriers along the footway so as to preclude crossing at surface level for some considerable distance—50 yds. or so—on either side of the entrance.

'The Design and Layout of Roads in Built-Up Areas' recognised that subways were unlikely to be popular with pedestrians. Barriers at road level to force people into the subways were seen to be the answer. (Author's collection)

'ALBION ROAD PLAN WILL BE DISASTROUS FOR THE TOWN . . .'

OVER 600 SIGN PROTEST PETITION

Shields Weekly News, 7 January 1972 (Courtesy of Johnston Press North East)

'Welcome to North Shields Town Centre' Albion Road dual carriageway style. Subways were proposed to provide safe access to the town centre under the improved road. The pictured subway is at Preston Road North, built during the same period to provide access to the suburban Preston Grange Shopping Centre, when this road was also improved to a dual carriageway. (Malcolm Rivett)

announced a £64 million cut in road building in the Tyne-Wear area. For Tynemouth the casualties were, unsurprisingly, the Albion Road scheme, and also the dualling of Beach Road between Billy Mill and Preston Road North, which had been scheduled for 1975–76. In terms of Albion Road there appeared to be almost a sense of relief within the council at the announcement, Councillor McArdle, chairman of the Town Improvement Committee, describing the scheme as 'a dead duck anyway'. More concern was raised at the cancelling of the Beach Road scheme, which would remain unimproved until its widening (although not to dual carriageway standard) in 2016.

While the Albion Road dual carriageway scheme mirrored the 'on-off, on-off' redevelopment of North Shields town centre more generally, it could so easily have

The Albion Road, Tynemouth Road, and Stephenson Street (behind the trees) junction in 2017. This would have been the eastern end of the Albion Road dual carriageway where a large roundabout was proposed. The site was developed in the 1980s for the Magistrates' Court (extreme left of the photograph). The tall building is Stephenson House, a mid-1970s office block and part of the overall town centre redevelopment scheme. In 2016/17 this was converted to residential apartments. (Malcolm Rivett)

gone ahead. Plenty of other similar road schemes, subject to the same objections of severance, were built in the 1960s and 1970s on the grounds that traffic needed to flow. If built, one can only speculate on the effect it would have had on the town centre; perhaps easier access for car owners would have helped it more successfully fight off competition from out of town supermarkets and retail parks, or maybe it would, as feared, have severed the town centre from its catchment area and the road would have become a race track out of the town rather than into it.

In the twenty-first century there has been a reaction against dual carriageways in town and city centres in particular. In some instances more money (in actual, if not real, terms) has been spent narrowing and taming these roads, and replacing subways with level pedestrian crossings, than it cost to build them in the first place. So, had the Albion Road dual carriageway been constructed, we would perhaps today be looking at an artist's impression of proposals for a traffic-calmed, tree-lined and cycle-pathed Albion Boulevard, to be implemented 'if only the money can be found'.

Chapter Three

Tynemouth, Queen Resort of the North East

It is reputed that the fashion for visiting the seaside, initially for health and later for enjoyment, started in Scarborough in 1626 with Elizabeth Farrow's discovery on the town's beach of a spa of acidic water. The arrival of the well-to-do in Tynemouth to engage in sea bathing, albeit on a very limited scale, would have come with the extension of the Newcastle and North Shields railway to Tynemouth in 1845. Lamberts' 1860s *Handbook to Tynemouth* stated:

> The little watering place of Tynemouth is year by year assuming more and more the character and proportions of a fashionable town Every summer hundreds of strangers from all parts of the kingdom come here to seek health, or change or pleasure; and from May to October, beauty and fashion, in the streets, on the cliffs, and along the sands – for we meet them everywhere – indicate the increasing popularity of the village.

This increasing popularity of Tynemouth brought, in the 1870s, a proposal for a massive winter garden complex that would cascade in a series of terraces down the full height of the cliff at Longsands.

Designed by architects Norton and Masey, who were behind various similar projects elsewhere around the British coast, the main building and the first two terraces were constructed pretty much as indicated in the artist's impression and opened in August 1878. The curved, glazed roof ensconced the winter gardens and the towered pavilions to either side contained refreshments rooms. In the basement there was an aquarium.

The parts of the plan that didn't happen, however, were the shore level pedestrian promenade and pavilion, nor were the cliffs tamed with paths and landscaping to the degree originally envisaged. As a result, the complex had a semi-finished appearance, incongruously perched halfway down the cliff. The inability of elegantly dressed Victorian ladies and gentlemen to enjoy the indoor social events and entertainment before or after processing along the shore, without the inconvenience and discomfort of trogging through the soft sand, may well have contributed to the limited success of the Tynemouth Winter Garden. Lynn Pearson

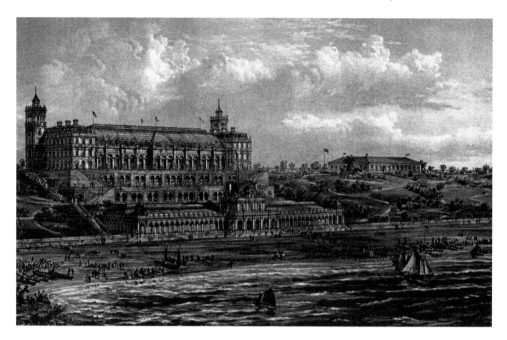

Tynemouth Winter Garden as envisaged prior to construction in the 1870s. The shore-level pavilion, colonnade and promenade never materialised. (Author's collection)

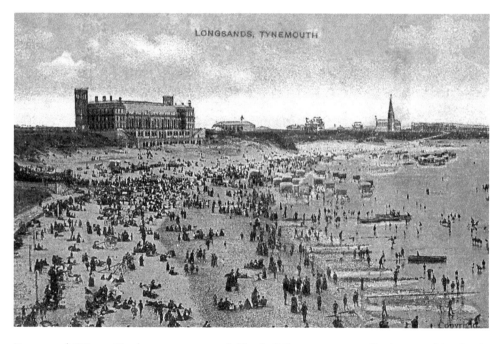

Tynemouth Winter Garden as constructed. The building was eventually destroyed by fire in 1996, although the shelter to its immediate right still stands today. The next building along was Beaconsfield, a private house and the subject of much debate in the 1950s and 1960s. (Author's collection)

(*The People's Palaces: Seaside Pleasure Buildings 1870–1914*) reported that within a year of opening, concerts and readings were replaced by more popular entertainments and by 1880 the building had been sold at auction. It changed hands frequently thereafter, constantly being modified and adapted to cater for the latest crazes in entertainment, while the elegance of its structure gradually fell into decline. The building's eventual destruction by fire in 1996 was very sad, but at the same time a relief to many.

The story of the Winter Garden illustrates the dilemma faced by Tynemouth, in common with many seaside towns, in the period from the 1870s through to the First World War: whether to remain a select resort with quiet, refined entertainments designed to appeal to the middle classes, or whether to go downmarket in an attempt to attract the masses.

TYNEMOUTH OF THE FUTURE

By the 1930s this dilemma had, to a large degree, resolved itself as those with money were increasingly shunning British seaside resorts for continental destinations. Meanwhile, the working classes had more money and free time to visit the seaside, particularly for day trips.

In 1933, Tynemouth Corporation borough surveyor John L. Beckett published 'Tynemouth of the Future – a few suggestions regarding the potentialities of Tynemouth as a seaside resort'. In the report Beckett argued that it was 'obvious' that Tynemouth should develop more and more as a health resort and holiday centre because of its natural beauty so that the town should prosper. 'It is essential' he said 'that a bold and progressive policy be adopted in order to provide those facilities so necessary to the holiday maker'. Accompanying the report was a 2-feet-long sketch plan showing the various improvements proposed along the seafront from Sharpness Point (at the south end of Longsands beach) to Cullercoats Bay. This included impressions of the various buildings proposed in streamlined, moderne style. Clearly recognising council members' parsimonious tendencies, Beckett emphasised that it should be clearly understood that his extensive and far-reaching plans would not involve the Corporation in any immediate expenditure.

The plan's main proposal was the construction of a marine drive and promenade along the full length of Longsands between the then (and still) existing ramped approaches to the beach at its northern and southern ends. While an echo of the promenade proposal of the 1870s, this would incorporate a 30-feet-wide carriageway for motorcars and light vehicles. Numerous pedestrian ramps and stairs would link the new marine drive with Grand Parade on the top of the cliff.

Many new facilities were proposed along the marine drive. To the south of the Plaza (the contemporary name of the Winter Garden) was to be a municipal café, incorporating a large beach tent and chair store, with a first-floor-level tea terrace and sun loggia. These would overlook a children's paddling pool 135 feet long by 50 feet wide, together with 'tastefully designed' kiosks for the sale of sweets and papers, etc. Next there would be a row of seventeen shops laid out along a curved colonnade, behind which would be a car park.

These proposals, presented to the council's General Purposes Committee on 14 February 1933, were not received with great enthusiasm.
(Author's collection)

(Courtesy of Johnston Press North East)

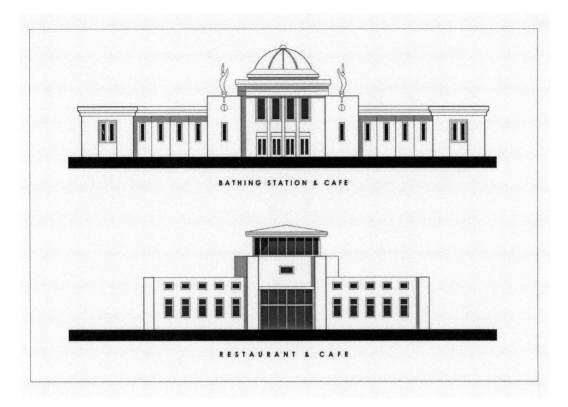

Surviving plans of the 1933 *Tynemouth of the Future* proposals are of poor quality. This modern-day reproduction illustrates two of the buildings proposed. The bathing station and café would have been in the middle of Longsands Bay, a little way to the north of the Plaza. The restaurant and café would have been located under the cliffs at Cullercoats Bay, overlooking the proposed outdoor bathing pool. (Courtesy of Paul Gilmartin of pjgdesign.co.uk)

To the north of the Plaza the existing public shelter (which still stands today) would have been demolished and replaced by a café and a circular shelter set in formal gardens. Below this, at beach level a bathing station was to be built to provide dressing cubicles and hot and cold showers. Beyond that the then 'existing mess of bungalows and ugly huts' was to be replaced by 101 day bungalows, with folding glass doors, set on a two-level curved terrace. A grand staircase and a cascade fountain would form the central feature of the terrace. At the northernmost end of Longsands a large public shelter and conveniences were to be constructed.

At the southern end of the bay a pedestrian promenade would hug the cliffs of Sharpness Point. This would link the open-air bathing pool, which had opened in 1929, with King Edward's Bay to the south. Along this promenade would be gardens and a bandstand.

The most audacious aspect of the plan was the creation of a massive bathing pool on the south side of Cullercoats Bay. This would be achieved by extending the bay's south pier inwards to the land. Beckett explained that the pool would have 'all the

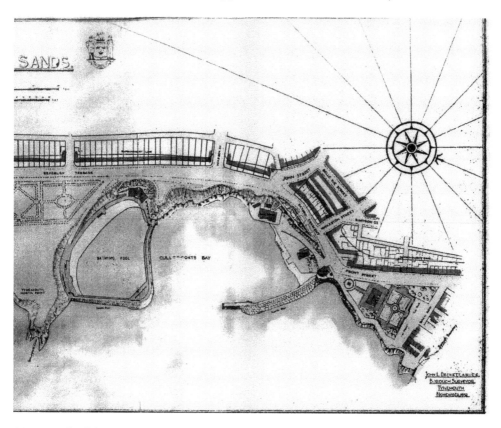

'Tynemouth of the Future' was accompanied by a plan illustrating the proposals of more than 2 feet in length. This is the northern end of the plan showing the open-air bathing pool to be created in Cullercoats Bay. (Author's collection)

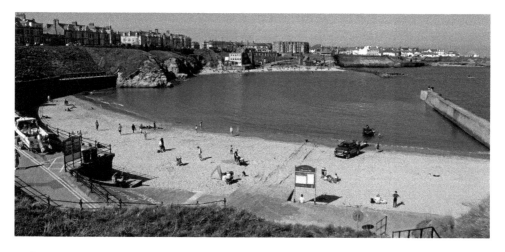

Cullercoats Bay in 2017. The 1933 proposals would have seen the pier on the right of the photograph extended inland to the cliffs to create a seawater bathing pool. A bathing station, a shelter, a café and a restaurant would also have been provided. (Malcolm Rivett)

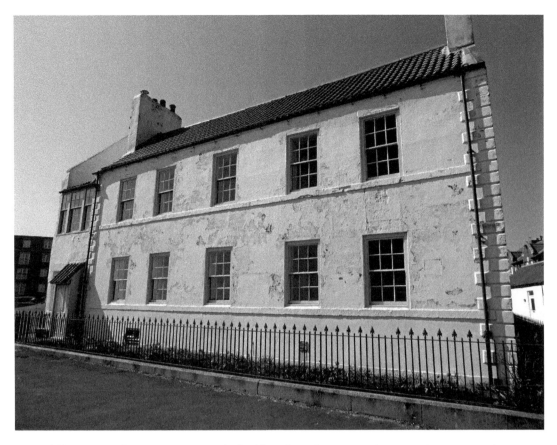

Cliff House, Cullercoats, in 2017. The building dates from around 1768 and is now Grade II*
listed. It and the surrounding property was to have been demolished to make way for sunken
gardens, a café and a shelter. (Malcolm Rivett)

natural facilities of a plage and beach'. A large bathing station, a shelter, a café and
a restaurant would be provided to service the bathing pool. Finally, the 'mostly
dilapidated and certainly unsightly' property, between Front Street and the cliff edge
to the north of Cullercoats Bay, would be demolished and replaced with sunken
gardens, a café and a shelter.

The plan received a lukewarm response when presented to the council's General
Purposes Committee in February 1933. Letters to the *Evening News* expressed
concern at expenditure being incurred to attract even more day trippers to Tynemouth
and suggested that its natural attractions should be left for local residents to enjoy.
Beckett's idea that the plan could be implemented without initial expenditure by the
Corporation also seems to have been a somewhat naïve one. Private enterprise might
possibly have funded the construction of cafés and kiosks but in reality this was not
possible without first building the marine drive. And who other than the council was
going to pay for that? Unsurprisingly, nothing immediately happened in implementing
the plan and within a few years the country was plunged into the Second World War.

BEACONSFIELD – THE WHITE ELEPHANT THAT WASN'T

In the late 1940s British seaside resorts had never had it so good, in terms of the numbers of visitors at least. Many resorts had been all but out of bounds for six long years of war and, consequently, the pent-up demand to spend a day at the coast was enormous. In its centenary celebration publication *Tynemouth 1849-1949* the Corporation predicted that holidays with pay would bring ever larger numbers to Tynemouth and, thus, more cafés, shelters and sunken gardens would be needed. However, Beckett's plans of fifteen years earlier for Longsands and Cullercoats Bay appeared to be have been forgotten: the future lay at Beaconsfield.

Beaconsfield, a large private house, stood a short way to the south of St George's Church at Cullercoats, on the landward side of Grand Parade. In 1947, the council secured parliamentary powers to demolish the house and develop the site and adjoining land as a winter garden, incorporating cafés, provision for orchestral concerts, dancing and 'probably roller-skating'. A hotel was to be built near to the church and a new station, to be called Longsands, would be constructed on the adjacent railway line.

However, these were times of austerity and the limited public money that was available was mostly directed towards building new homes. Whilst people flocked to Tynemouth in their thousands on warm days, most were day trippers, not in need of a hotel and few had much money to spend. And, anyway, was a winter garden a realistic proposition when the Plaza, increasingly dilapidated and desperate for custom, stood a few hundred yards away? As for the new station, the existing Tynemouth and Cullercoats stations were not far away, and on the busiest summer days it was the capacity of the trains not the stations that was the problem. It is not surprising, therefore, that nothing immediately happened on the site.

In July 1959, no doubt frustrated by the lack of action, the Parks and Sands Committee instructed the borough surveyor D. M. O'Herlihy to prepare updated development options for the site. These included indoor swimming pools, which could be adapted for dancing, a restaurant, a public house, and a thirteen-storey hotel. Residential accommodation, in the form of four or five ten-storey blocks of flats, was also to be provided, along with tennis courts and a children's playground or miniature golf course.

Expressions of interest in taking forward the scheme were invited nationally but ultimately by 1960 only one proposal had been submitted for the council's consideration. M. J. Liddell & Son Ltd of Newcastle proposed a development comprising a single block of multistorey flats, a first-class hotel, a shopping/restaurant block, a petrol filling station and car parking facilities. Clearly this was a development designed predominantly to cater for residents rather than trippers or holidaymakers.

Nonetheless, much was made of the hotel proposal, which it was suggested could be based on the Caribe Hilton Hotel at Puerto Rico, which John Liddell had been impressed by on his recent travels. The hotel was to have fifty conventional bedrooms and fifty suites of several rooms. Negotiations then took place between the council

and developer, focussing on the sale price for the land and the phasing of the scheme. The council wanted a guarantee that the hotel would definitely materialise and would do so early on in the development. In July 1962, Liddell announced that in the economic situation of the time a scheme according with the council's requirements would not be feasible.

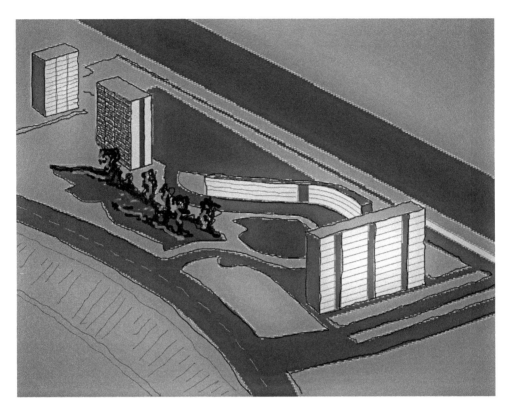

An illustration of a model of M. J. Liddell & Son Ltd's Beaconsfield site scheme, based on a photograph in the *Weekly News*, 17 June 1960. In contrast to earlier schemes for the site, residential flats dominated the proposal. (Courtesy of Paul Gilmartin of pjgdesign.co.uk)

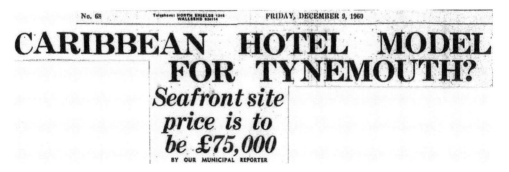

(Courtesy of Johnston Press North East)

The Caribe Hilton Hotel, Puerto Rico, in 2010, said to be John Liddell's inspiration for his 1960 redevelopment scheme for the Beaconsfield site. Without the palm trees, which would have been unlikely to survive on Tynemouth seafront, the hotel is perhaps less exotic than its name suggests. (https://www.flickr.com/photos/vxla/5299352764 under Creative Commons 2.0)

In September 1964 the borough surveyor proposed yet another concept for the site. The swimming pool, winter garden, hotel and even flats had been abandoned and, costing £118,000 (around £2.2 million in today's prices), the proposal was to simply convert the site to a surface car park for 430 cars and thirty buses, with a subway under Grand Parade to the beach. An alternative underground and raised car park, providing three levels in total, would cost an extra £261,000. Council officers clearly thought that providing somewhere for the rapidly increasing band of car owners to park their vehicles was more important in attracting them to Tynemouth than offering leisure and entertainment facilities. In his July 1965 'Report on the Sea Front' O'Herlihy, now in his fourth decade as the borough surveyor, summarised the Beaconsfield situation: 'To try and obtain development on the site might result in a further ten years of discussion and a white elephant at the end of it all.'

Even this car park scheme didn't actually happen, probably partly explained by car owners abandoning Tynemouth for day trips realising that, instead, they could now reach previously inaccessible stretches of coast and rural beauty spots. Eventually, grass

mounds were formed around the edge of the Beaconsfield site to encourage its use for picnics, although this was of limited success. While the mounds might be effective as a windbreak they also block the views of the sea that visitors come to Tynemouth to enjoy in the first place. Finally, in the 1990s the Sea Life Centre aquarium was constructed on the southernmost part of the site.

Today, the coast at Tynemouth is enjoyed for its relatively unspoilt natural beauty. Cafés at the northern and southern ends of Longsands Bay provide for visitors needs and it is difficult to imagine much demand now for a bathing station on the beach washed by the cold currents of the North Sea. Furthermore, had it been constructed, would the massive Cullercoats Bay bathing pool today be any less derelict than is the Tynemouth outdoor pool that was actually built? Certainly, cars zooming, crawling or parked along a concrete marine drive running the full length of Longsands would add little to Tynemouth's attractions.

Beaconsfield in 2017 without the swimming pool, winter garden, hotel or apartments, all proposed for the site at various stages over the years. A wasted opportunity? (Malcolm Rivett)

Longsands Beach in 2017. The marine drive, proposed in 1933, would have continued the existing vehicular ramp (foreground of the photograph) along the bottom of the cliff to the northern end of the beach near St George's Church. (Malcolm Rivett)

Chapter Four

Other Schemes that Might Have Been

ROYAL QUAYS

In the spring of 1990 I took part in a university field trip to a post-industrial wasteland, somewhere between Howdon Road and the River Tyne. Clambering off the coach we were ushered into a Portakabin that appeared to have landed, Tardis-like, among the desolation. Inside we gazed with wonder at cleverly lit, glossy displays and carefully crafted scale models as representatives of the Tyne and Wear Development Corporation set out their stall. The site, the Albert Edward Dock and its acres of surrounding railway sidings, warehouses and timber yards, was to be transformed into a new community of hundreds of homes, parks, a marina, shops and leisure facilities. Always the sceptic, I recall thinking 'Pull the other one' (or thoughts to that effect).

Six years later I moved to live in North Shields to find that the Development Corporation's plan had been realised. OK, the architecture may be a bit more run of the mill than the models had promised, and there aren't as many smiling children with balloons in the park as the glossy displays suggested, But, in essence, this was a plan that did happen: the marina, filled with yachts and overlooked by houses and flats, the outlet shopping centre, Wet 'n Wild water park and a bowling alley are all there, connected by now mature and still well-maintained parkland.

Royal Quays arose out of a design competition held by the Development Corporation. Bidders worked to a brief that specified the main types of development to be incorporated into their schemes. However, innovation was encouraged in respect of the detail. In terms of leisure facilities in particular, the unsuccessful bids show some novelties that the residents of North Shields and Tynemouth have missed out on.

One of the bids was submitted by Focus, which described itself as a federation of community specialists. Its plans envisaged a massive leisure centre that would feature a leisure pool, sports hall, ice rink and tennis centre. The pool was to have a *Treasure Island* theme, with sand, palm trees and a pirate ship. There would also be an Olympic-standard diving pool, a Jacuzzi and a beach spectator area. The ice rink would be hydraulically controlled so that it could be raised into three separate levels for ice discos and spectaculars. A somewhat Orwellian-named Central Control Area

would incorporate a restaurant, amusements and a solarium. A railway station would be built, which would be served by steam trains, and the whole complex was to be of modern-day, Crystal Palace-style design.

The steam railway idea was not quite as far-fetched as it might seem. The Stephenson Railway Museum at Middle Engine Lane had opened in the early 1980s and in 1989 railway track had been laid as far as Percy Main, only a few hundred metres from Royal Quays, on which steam-hauled trains were run for museum visitors. The alignment had been part of the huge network of mineral lines linking the area's collieries with the coal staithes at Albert Edward and Northumberland Docks. Then, in the mid-1970s, it had been used as a test track for metro trains.

McAlpine/Rockfort's bid included a 10,000-seat multipurpose arena. Again this was perhaps not quite as unlikely as it now sounds given that a similarly sized venue, today the Metro Radio Arena, opened in Newcastle around five years later. Even the winning bid from Royal Quays Development Consortium included plans that ultimately didn't see the light of day. There was to be the UK's first indoor ski centre with real snow and an ice park with polar bears. For the sake of animal welfare one can only hope that, unlike the snow, the polar bears would not have been real. A proposed multiscreen

A Crystal Palace-style steam railway station and leisure centre, one of the unsuccessful proposals for Royal Quays. (Author's Collection)

cinema also failed to materialise and until the present-day Odeon opened at Silverlink Retail Park in the late 1990s, people would have to continue to travel outside North Shields and Tynemouth to visit the cinema.

FISHY BUSINESS – THE PORT OF TYNE AUTHORITY, THE COUNCILS, THE GOVERNMENT AND THE EEC

North Shields owes its existence to fishing and over the centuries facilities for unloading and servicing of fishing vessels and for the marketing of the fish were built, adapted and replaced around the mouth of the Pow Burn, a small tributary of the Tyne, the source of which is on the present-day Tynemouth Golf Course.

In the early 1970s the fish quay facilities were in a poor state of repair and considered to be inadequate to enable North Shields to successfully compete with other East Coast ports, including Peterhead, Hull and Grimsby. Notwithstanding this, fish landed at North Shields had increased from 12,600 tons in 1961 to 41,000 tons in 1971. However, the Port of Tyne Authority was of the view that, whatever upgrade was carried out, space limitations would always restrict the number of vessels that could be accommodated at the existing fish quay.

Consequently, in September 1972 the authority proposed a new £3-million (around £36 million in today's prices) 'huge, modern fish dock' to be sited in the bay below Knotts flats, between the existing fish quay and the mouth of the river. It was envisaged that the dock would enable two trawlers and twenty-four fishing boats to land their catch at any one time. Waiting and lying-up berths would provide for four trawlers of up to 150 feet in length and eighty seine net boats of up to 80 feet in length. It was recognised that the new dock walls might affect the patterns of currents and waves and it was stated that advice on this matter was to be sought from the Hydraulic Research Station. It was also pointed out that the Tynemouth lifeboat house and slipway would be a casualty of the scheme and would need relocating. However, it was indicative of the period that the effect on the ecology of the inter-tidal Black Middens rocks, on which the dock would be constructed, did not appear to be a key consideration. That said, prior to the cleaning-up of the Tyne, the ecological value of the river was minimal and the Black Middens were very well named.

The timing of the plan had no doubt been influenced by a government announcement that 60 per cent grants for such proposals would be available for schemes approved by May 1973. However, doubt was expressed locally as to whether the Port Commission would be able to find the other 40 per cent required to build the dock. Certainly, the working party set up by the port, with representation from the Tyne Fisheries Advisory Committee, the White Fish Authority, the Ministry of Agriculture, Fisheries and Food and Tynemouth Corporation, could not find a solution to this particular problem.

In March 1973, supported by Dame Irene Ward, MP for Tynemouth, the Port Authority requested an extension of the government's deadline for grant funding. Then in June of that year Tynemouth Corporation approved a contribution of £374,000 to cover approach roads and other ancillary works. This was arguably an easy decision to

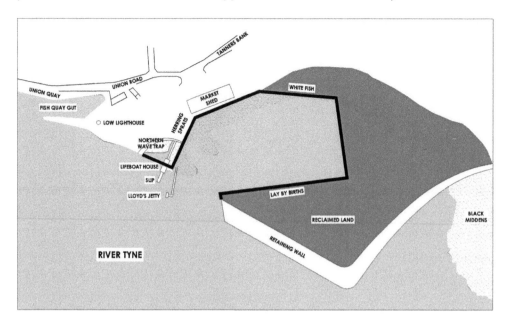

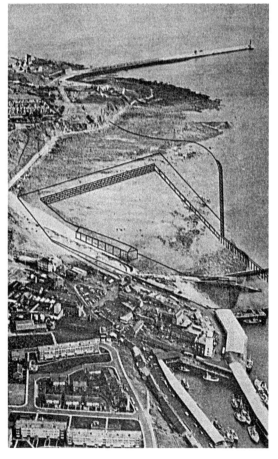

Above: The *Shields Weekly News* stated that the Port of Tyne Commission's proposed new fish dock would involve the reclamation of a 'big slice of the lower Tyne harbours immediately downstream from the existing Fish Quay'. The scale of the proposed dock, in comparison with the old quay (Fish Quay Gut), is clear to see. (Courtesy of Paul Gilmartin of pjgdesign.co.uk)

Left: An aerial montage of the proposed fish dock. The character of the river between North Shields and Tynemouth would have been radically altered. (Author's collection)

make for an authority always so reluctant to spend money; in its final year of existence the Corporation was in effect committing its successor, North Tyneside Council, to involvement in the scheme, which it was estimated to be the equivalent of a 0.4 of a penny increase on the new authority's rate.

Finally, some progress appeared to be made and in early 1974 a private bill to authorise construction of the scheme began to make its way through Parliament. In May of that year the Port Authority sought expressions of interest from contractors wishing to build the project. Then, in October 1974, only four months after Arndale had pulled out of the town centre shopping scheme because of rising costs, it emerged that the new fish dock had risen in price from £3 million to £5 million. Norman Buchen MP, the junior minister responsible for the grant funding decision, said 'Leaving aside the necessity for the Port of Tyne Authority to obtain certain statutory consents, the present position is that the estimated cost of the project has increased so much that we are all, including the Port of Tyne Authority, having to do our sums again to see whether it can go ahead'.

On 1 January 1973 the United Kingdom had joined the European Economic Community (EEC) and with Parliament and the country divided over the matter a referendum as to whether or not the country should remain part of the community was held on 6 June 1975. It was surely not a coincidence that the day before the referendum the *Weekly News* reported that Neville Trotter, Tynemouth's new MP, had received word from Sir Christopher Soames, vice-president of the European Community, that there was a possibility that a 25 per cent grant towards the new fish dock in North Shields would be forthcoming from the Common Market Agricultural Fund. The country voted to remain in the EEC by 67 per cent to 33 per cent.

However, only a month later, before formal grant application to the EEC could be made, the UK Government pulled the plug on the dock, formally refusing both the grant application and approval for the scheme itself under Section 9 of the Harbours Act 1964. An immediate lobbying campaign by the Port of Tyne, Neville Trotter MP and both North Tyneside and Tyne and Wear County Councils failed to change the government's mind. Even worse, Ted Bishop MP, Minister of State at the Ministry of Agriculture Fisheries and Food, warned that common market funding should not be relied on either as the funds were limited and were only given if a contribution from the member state government was also made. However, the government did approve a 60 per cent grant towards the £270,000 rehabilitation of the existing Fish Quay at North Shields, on which work started in November 1975. While better than nothing, no doubt many thought that improvement of the old facilities made realisation of the new fish dock an even less likely prospect.

Nonetheless, the campaign for funding for the new dock continued into the late 1970s, although it became increasingly entangled in the government's and the EEC's wider policy on fisheries and efforts to prevent overfishing. A direct approach by Tyne and Wear County Council to the EEC in 1977 for a loan for the project, by then estimated to cost £10 million, was refused on the basis that financial aid would not be given to projects that were seeking to increase production – i.e. the amount of fish being caught. Then, with the improvements to the existing quay complete and

the construction of new fish processing units on adjacent land underway, the impetus behind the new dock began to falter. With reference to the project in March 1979, the Port of Tyne Authority appeared to be only able to bring itself to say that the government would review the need for the dock in 1982. In reality, the scheme's time had been and gone and little more was heard of it again.

Thirty-five years on and the country has once again (June 2016) voted in a referendum on Europe, this time 52 per cent to 48 per cent in favour of leaving what has now become the European Union. Currently, one can only speculate on the implications of this for the North Shields fishing industry and the need and justification for any new dock facilities to support it. However, since the dock was first proposed in the early 1970s, the Black Middens, which emerge on each tide from the now pollution-free Tyne, have become a feeding ground for wading birds. A pedestrian promenade skirts the bay linking the bars, restaurants and cafés of North Shields fish quay with the attractions of Tynemouth and is hugely popular amongst joggers, dog walkers, bird watchers and afternoon strollers. It is almost certain that if the dock scheme were to be resurrected today there would be loud objections from many more people than simply those being asked to pay for it.

Black Middens in 2017, the site of the proposed fish dock scheme. One cannot imagine that resurrection of the project today would result in anything other than a storm of protest. (Malcolm Rivett)

TYNEMOUTH AIRPORT

The First World War demonstrated the potential of aeroplanes and by the late 1930s a network of commercial flights had been developed in Britain, linking a number of main cities, Ireland and the near continent. Several iconic airport buildings in the modern style of the period were built, including the municipal ones at Liverpool (Speke) and Birmingham (Elmdon). The Second World War brought a complete halt to these services and most airports were taken over by the government.

In the immediate post-war period it was assumed that air travel would boom and many large towns and cities believed the provision of an airport or aerodrome was essential to their prosperity. Tynemouth was no exception and post-war planning, set out in *Tynemouth 1849–1949*, initially envisaged the construction of an aerodrome on fields between Preston Village and Rake Lane.

However, the concept of an airport in most main towns, as part of a comprehensive network of inland air services competing with and potentially replacing the railways, completely misjudged the realities of the post-war growth in air travel. Instead, a relatively small number of regional airports (Newcastle for Tyneside and the wider north-east) were developed, able to attract sufficient passengers to justify non-stop long-distance routes to the furthest cities in the country, the near continent and, most importantly, to the Mediterranean for package holidays.

It is therefore unsurprising that the plans for an airport in Tynemouth fizzled out before they officially got off the ground. In the 1960s and 1970s the site earmarked for it was developed, in part, as the Preston Grange housing estate and then in the 1990s for Morrisons supermarket. However, it is interesting to wonder what such an airport would have looked like had it become a reality.

AERODROME.

It is generally agreed that all big towns and busy seaside resorts should have aerodromes, and a population of 100,000 within a radius of twenty miles is taken as a basis. With such a population there is of necessity much movement, and this is particularly the case in the summer at seaside resorts.

Air transport is likely to develop for—(*a*) very long, fast, non-stop journeys, and (*b*) short journeys between places now inadequately served by the railway. Some authorities contend that air lines should only be permitted where they can create new movement, and should not attempt to compete with other and existing methods of transport. There are many routes which by running diagonally to the main railway line would offer greatly improved communications, and so create new movement. By its speed air transport should encourage journeys that time would not allow by other means. The week-end visitor to the seaside would find an added zest to his brief holiday in the rapid journey by air, which would enable a visit to be paid to distant seaside places, otherwise impossible in the time available. The week-end habit is growing.

An extract from the 1938 development plan for Scarborough. These sentiments would have no doubt been in the mind of Tynemouth Corporation in the years immediately following the Second World War. (Author's collection)

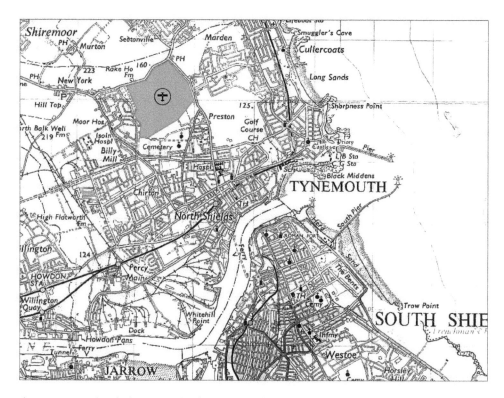

The site proposed in the late 1940s for the Tynemouth Aerodrome. Today the Preston Grange housing estate and Morrisons supermarket dominate the site. (Courtesy of Paul Gilmartin of pjgdesign.co.uk)

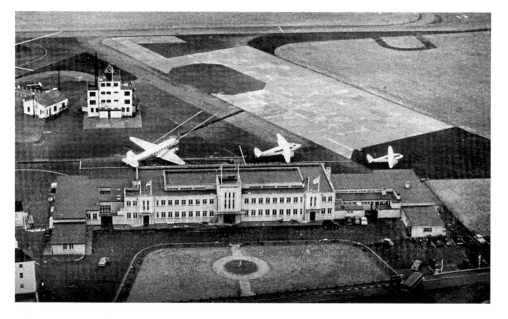

The new terminal building at Ronaldsway, Isle of Man, opened in 1954. An indication of what might have been for North Shields and Tynemouth? (Author's collection)

Morrisons supermarket in 2017, a building not dissimilar in appearance from a modern-day airport terminal. Imagine checking in for a flight to London or Southampton here, rather than doing the week's shopping. (Malcolm Rivett)

INDOOR SWIMMING POOL – HERE OR THERE?

In the late 1950s the council resolved to build an indoor bathing pool, believing that the outdoor pools at Tynemouth (Longsands) and at Hawkey's Lane in North Shields were not adequate for modern, year-round bathing requirements. The government had also announced that approval for loans for swimming pools was likely to be forthcoming. In 1959, two possible sites for the pool had been identified: playing fields near the junction of Beach Road and Preston Road and the disused Brock Farm reservoir site behind Preston Hospital.

Debate between factions in the council raged for five years or more over which site was the most suitable. In its favour the playing field site was considered to be easier and cheaper to develop, while Brock Farm was argued to be more central and better located for bus services, albeit that preparing the reservoir site for new development was likely to be costly.

The Preston playing fields site won the day and nearly fifteen years after it was originally proposed the '£350,000 Luxury Indoor Swimming Pool' (around £4.5 million today) was officially opened in October 1971.

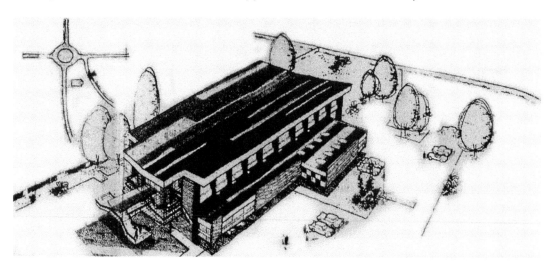

The indoor swimming pool proposed on playing fields at Preston as it appeared in the *Shields Evening News* on 27 September 1963. (Courtesy of Johnston North East Press)

Tynemouth indoor swimming pool in 2017. Eventually built in 1971, the pool was similar to the proposals of 1963, although its orientation was altered to align with, rather than sit at a right-angle to, Beach Road. (Malcolm Rivett)

1989 vintage town houses and apartments on the former Brock Farm reservoir site in 2017. Throughout much of the 1960s the site was advocated by one faction in the council as the most appropriate location for the proposed indoor swimming pool. The housing estate is home to both nesting seagulls and domestic cats, but the seagull sitting on the ridge of the archway and the white cat chasing it from below right are plastic. (Malcolm Rivett)

The Brock Farm reservoir site lay derelict for nearly two more decades. In 1989, Barratt developed the site for a mix of houses, town houses, bungalows and apartments.

BOWLING ALLEYS – BILLY MILL AND PRESTON GRANGE

Ten-pin bowling has ancient origins but its modern incarnation dates back to 1946 in the USA and the introduction of the first automated 'pinspotter', which replaced the manual resetting of the pins by 'pin boys'. The subsequent massive growth in the popularity of the game hit this country in 1960 with the opening of Stamford Hill and Golders Green bowling alleys in north London.

During a period of increasing leisure time and disposable income the appeal of the game was multifaceted. It could be played all-year round, whatever the weather and in daylight or darkness; it could be enjoyed by all ages playing as couples or in big groups; no particular skill or expertise was needed to have a good time; and there was the element of novelty and glamour associated with the automated alleys and their American styling and origins. It is not surprising then that the 1960s witnessed a huge number of indoor bowling alleys opening across the UK. However, for every alley that opened many other schemes were proposed but did not materialise.

The first such proposal for North Shields emerged in September 1962. Rosspark (Links) Ltd's £250,000 'luxury bowling centre' was to be located on the site of Billy Mill, to the north of the Coast Road where Tynemouth Squash Club is now situated. In addition to twenty-four bowling lanes there would be a snack bar, a licenced bar, a club room and a children's nursery. It was stated that the centre would be open during the day 'allowing housewives and shift workers to play'. Planning permission was granted but, within a year, Rosspark announced that they would not proceed with the scheme, although no reason was given. The council advised that they were aware of interest from other potential operators and that a site for an alley in a more central location might prove to be more generally accessible than Billy Mill.

Meanwhile, in October 1962, plans were unveiled for a 'dream estate' – what would eventually be known as the Preston Grange housing estate – on the undeveloped land that had, in the 1940s, been earmarked for Tynemouth's aerodrome. Comprising 700 houses, the dream elements of the scheme were to be a shopping centre, an underground ballroom, a swimming pool, a bowling green, tennis courts and a nine-hole pitch-and-putt course. As the plans were developed the pitch-and-putt course was soon forgotten and the bowling green became a bowling alley.

Led by Newcastle–based firm M. J. Liddell & Son Ltd (who were also involved in the Beaconsfield site at Tynemouth), the housing came along quickly, the dream leisure facilities much less so. This was much to the chagrin of Tynemouth Corporation,

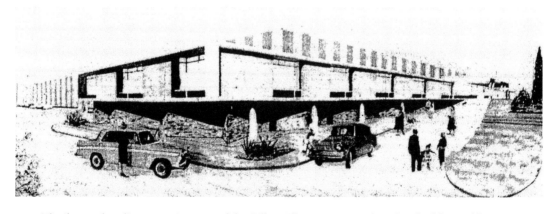

The 'luxury bowling centre' proposed for Billy Mill, as it appeared in the *Shields Weekly News* on 14 September 1962. Note the Ford Anglia, so evocative of the period. (Courtesy of Johnston Press North East)

Shop centre. underground ballroom in scheme

PLANS FOR A DREAM ESTATE AT SHIELDS

Shields Weekly News, 12 October 1962. (Courtesy of Johnston Press North East)

who had approved the development on the basis that it would be of benefit to the residents of the whole borough. On an almost monthly basis changes were made to the leisure facilities that were proposed to be provided. The swimming pool became a paddling pool and was then abandoned altogether. A hotel was proposed, shortly afterwards to be replaced by proposals for serviced flats. An idea for a rock garden or conservatory came and soon disappeared.

Then, once people moved into the new houses, the dream facilities became a nightmare. The bowling alley caused particular controversy; the new residents valued their quiet suburban homes and feared the youths, noise and disruption that this particular amenity might attract. Initially, the council stood firm, reiterating their view that the estate was designed to benefit the whole of Tynemouth and pointing out that residents had moved to the area in the full knowledge that leisure facilities were part and parcel of the development.

In early 1965, facing strong public pressure, the council began to show signs of relenting and sought advice as to whether or not compensation would be payable if planning permission for the bowling alley were to be revoked, bearing in mind that the developer had departed from the original plans for the estate. Unfortunately for the council it was deemed that compensation would be due. On the other hand it wasn't entirely clear that the developer wanted to include the bowling alley in the scheme anyway. Liddell's interest in the commercial aspects of the estate had been passed to Controvincial Estates. The *Weekly News* was clear in its view on the matter: 'to site a bowling alley on an estate of this standard was far removed from the canons of good planning'.

Finally, in June 1965, a resolution to the debacle was reached and permission was granted for a revised commercial area for the estate without a bowling alley. The local residents had got their way and the council had avoided a big compensation payment. However, until a bowling alley eventually opened in the 1990s as part of the Royal Quays development, residents of North Shields and Tynemouth would have to continue to travel some distance to live the dream playing ten-pin bowling.

THE METRO

An account of the trials and tribulations of the development of the Tyne and Wear metro warrants a book in its own right, and since the scheme, largely as originally envisaged, was ultimately successfully constructed, it is not a tale of strict relevance to

this book. However, in connection with the system's development there are two plans that never happened that are of relevance to North Shields and Tynemouth.

The conversion of the North Tyneside loop and South Shields suburban rail lines to a modern metro system, with underground stations serving the heart of Newcastle city and Gateshead town centres, was first formally proposed in the Tyne-Wear Plan of 1971. In March 1972, the *Weekly News* reported that 'fast, quiet trains running on rubber tyres' were envisaged for the new system.

Rubber-tyred trains were first introduced in France in 1956, with the conversion of the steeply graded line 11 of the Paris metro, later followed by the introduction of rubber-tyred technology on lines 1, 4 and 6. Numerous other rubber-tyred trains have since been introduced across the world, particularly in the USA, Canada and Japan, and in the United Kingdom on the terminal shuttle services at Gatwick and Stansted Airports. The main advantages of rubber-tyred technology are faster acceleration, a smother and quieter ride and reduced rail maintenance costs. These benefits no doubt appealed to those involved in the early development of the Tyne and Wear metro, given that the speed of journey was seen to be important in attracting passengers and that high frequency services were to be operated in very close proximity to residential areas. The main disadvantages of the technology are higher energy consumption and the risk of tyre blowouts.

A rubber-tyred metro train, Paris. Initial plans for the Tyne and Wear metro envisaged use of this technology. (www.flickr.com/photos/elsie/7724554232 under Creative Commons 2.0)

For reasons that are not well documented rubber-tyred technology was abandoned fairly early on in the development of the Tyne and Wear metro. It was possibly considered to be one technological innovation too far for a scheme already pushing a number of boundaries in public transport provision in the UK.

In a 1981 Institution of Civil Engineers paper concerning the concept, organisation and operation of the Tyne and Wear metro, D. F. Howard, director General of Tyne and Wear Passenger Transport Executive (PTE) stated, 'The adopted philosophy is that surface stations should not be more complicated than a bus stop'. In relation to the existing British Rail stations taken over by the metro he added, 'Where possible, and within the planning constraints, the stations have been remodelled to suit the above basic requirements'.

The existing station at Tynemouth, dating from 1882, comprised two long main platforms, six shorter bay platforms, extensive buildings and a massive wrought-iron and glass overall roof. The station's glory days (with well-tended flower baskets hanging from the roof) were a distant memory and by the early 1970s most aspects

The type of shelter proposed to replace the station buildings at Tynemouth. This is Monkseaton metro station in 2017, although shelters of this type can be seen all over the Tyne and Wear metro system. (Malcolm Rivett)

of the station were in poor physical condition. Arguably, the facilities had always been excessive for the area's requirements and they certainly did not fit with the PTE's vision for metro stations. Thus, in 1972 restructuring of the station – in effect its demolition – was proposed.

Potential demolition caused particular concern to the Civic Trust for the North East who, together with North Tyneside Council, lobbied the PTE to think again. In the light of this, and also desperate to cut the ever-rising construction costs of the metro, in March 1977 the PTE agreed to reconsider and suggested that only the west side of the station might be demolished. Then, in November 1978, the PTE's hands were tied by the decision of the government to list the station in its entirety. This all but ruled out its demolition. Tynemouth was the terminus of the first section of the metro to be opened in August 1980. The station had received a cosmetic facelift in the form of the painting of the wrought ironwork in the PTE's corporate colour of cadmium yellow: cheap and cheerful but hardly in keeping with its Victorian origins.

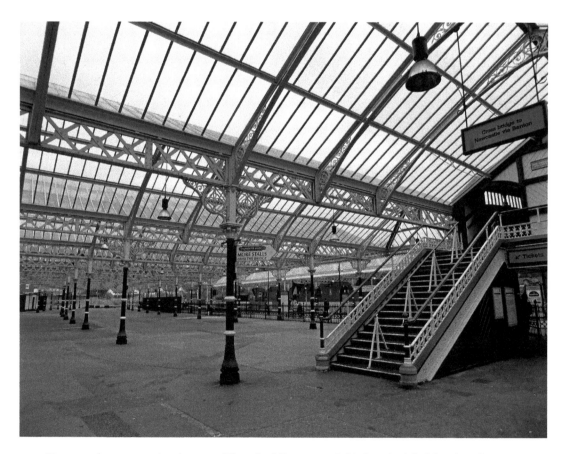

Tynemouth metro station in 2017. These buildings were initially scheduled for demolition as part of the conversion of the line to metro operation in the early 1970s. Listing of the station buildings in 1978 ruled this out. (Malcolm Rivett)

Later, the station would become the venue for a successful weekend flea market, although little was done to address its increasingly dilapidated structure. In 2007, English Heritage put the station on its 'At Risk' register of notable buildings in need of restoration. Inevitably the necessary money was hard and time-consuming to find but, eventually, full restoration work was undertaken and completed in 2012.

Today, Tynemouth Station is one of the architectural gems of Tyneside and few would now argue that its demolition is a plan that should have happened. Certainly, it is a struggle to imagine that the antique, craft and food stalls that throng under the spectacular glazed roof of the station each weekend would exist under the bus stop-type shelters proposed for the station back in 1972.

FLOATING RESTAURANT

In October 1966, the *Weekly News* reported the approval of permission for a riverside restaurant in a floating dock at a derelict jetty not far from the ferry landing at North

Clive Street, North Shields, in 2017, the site of the floating restaurant proposed in 1966. (Malcolm Rivett)

Shields – the idea of a Tynemouth businessman. The restaurant was to be built on stilts and would project 40 feet into the river, with room beneath for the mooring of yachts and cabin cruisers. Windows along three sides of the building were proposed to give commanding views of the river. Mr Gaisford A. Palmer, the promoter of the scheme, commented that he had had the idea for some time having seen similar buildings in Scandinavia. The cost was estimated to be 'anything up to £200,000' (about £3.5 miilion today).

Commanding as the views may have been, so too would have been the smells. This was a decade or so before the construction of the Tyneside interceptor sewer, when the untreated foul water of around a million people drained into the River Tyne. The plan was not heard of again.

WHAT'S IN A NAME?

Throughout the 1960s debate raged (within the circles that cared about such things at least) over the reorganisation of local government. At the time there was a hotchpotch of arrangements in England: county councils provided most key services but below them there were municipal boroughs, urban districts and rural districts, each of which were responsible for a different array of public functions. Complicating matters further, in many of the big towns and cities were county borough authorities responsible for all their own service provision, sitting within the surrounding counties like the holes in a Swiss cheese. And to add to the confusion, county boundaries divided many of the main industrial conurbations in two, including Tyneside, Teesside and Merseyside. It was also generally felt that many existing authorities were not large enough to professionally and cost-effectively provide modern services.

Of course, there were vested interests galore in the debate. From Tynemouth Corporation's point of view it could see the benefit of annexing its smaller neighbour, Whitley Bay Municipal Borough. However, it was strongly opposed to becoming subsumed within a much larger authority. A royal commission investigated the issue between 1966 and 1969 but even its members could not agree on the best way forward. Eventually the matter was resolved by the 1972 Local Government Act, which came into force in April 1974.

Tynemouth County Borough would be merged with Whitley Bay and Wallsend Municipal Boroughs, Longbenton Urban District and part of Seaton Valley Urban District. This metropolitan borough, together with ones focussed on Newcastle, Gateshead, South Shields/Jarrow and Sunderland, would sit within the Tyne and Wear Metropolitan County, which would be responsible for highways and various other strategic functions. While the form of the new authorities was settled, if not exactly agreed upon, the name for the new metropolitan district in which North Shields and Tynemouth would sit still needed to be decided.

Unsurprisingly, the constituent authorities each pushed for their own area to be dominant in the name, although with four main authorities of fairly equal size this was always going to be a non-starter. Historical names were suggested including Hadrian and Collingwood. Perhaps sensibly this idea was abandoned, one man's historical hero

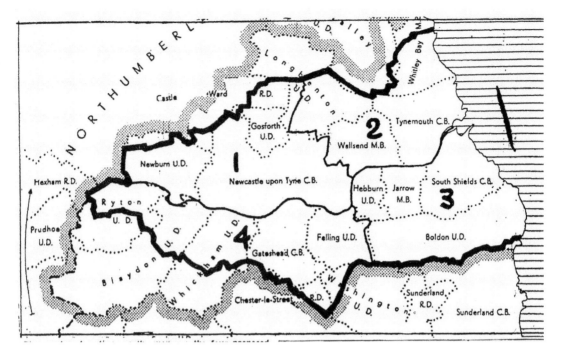

The Local Government Commission's 1962 proposals for Tyneside. What was to eventually become North Tyneside would, under this scheme, have been a smaller borough incorporating only parts of Longbenton Urban District and Whitley Bay Municipal Borough. An overarching Tyneside County Council was proposed, which was ultimately expanded to include Sunderland and named Tyne and Wear. (Courtesy of Johnston Press North East)

being another's despot. The most bizarre suggestion was Tynewhalton, made up from each of the main constituents' names – 'Tyne'mouth, 'Wh'itley Bay, W'al'lsend and Longben'ton'. The oddity of this artificial construct was exacerbated by the existence of the unusually spelt village of Whalton, not that far beyond the north-west extremity of the new district. I can attest to the hours of fun that can be had coming up with alternative names for the area based on this concept.

'North Tyneside' was finally settled on. While the *Shields Weekly News* derided it as dull and unimaginative, and suggested that public opinion should have been canvassed, it was geographically accurate and a name that each constituent authority could live with. No doubt similar discussions on the opposite side of the river, where South Shields County Borough merged with Jarrow Municipal Borough and Hebburn and Boldon Urban Districts, led to the name South Tyneside.

The existence of the metropolitan district has been challenged at various points over the years, particularly with the suggestion that North Shields, Tynemouth and Whitley Bay should be hived off as a separate 'Council for the Coast'. But unlike some others names of the 1974 reorganisation, such as Langbargh, renamed Redcar and Cleveland in 1996, North Tyneside as a name has lasted and there have been few calls for it to be renamed Tynewhalton.

Conclusions

Opinions will inevitably differ about each of the individual schemes, the stories of which have been recounted in this book. But arguably many people would agree that a graceful early nineteenth-century suspension bridge would today provide a spectacular gateway to the River Tyne, even if its practical use would be limited. And while there isn't a clear answer as to what should have been built on the site, Beaconsfield at Tynemouth, as little more than a patch of grass, is surely a wasted opportunity. On the other hand a major road bridge across the river, and the almost inevitable destruction caused by its approach roads, or a massive fish dock below the Knotts flats would probably much more detract from than enhance North Shields town centre and riverside.

So, are North Shields and Tynemouth better as they are today than as they might have been? Ultimately, that's a question that is impossible to answer.